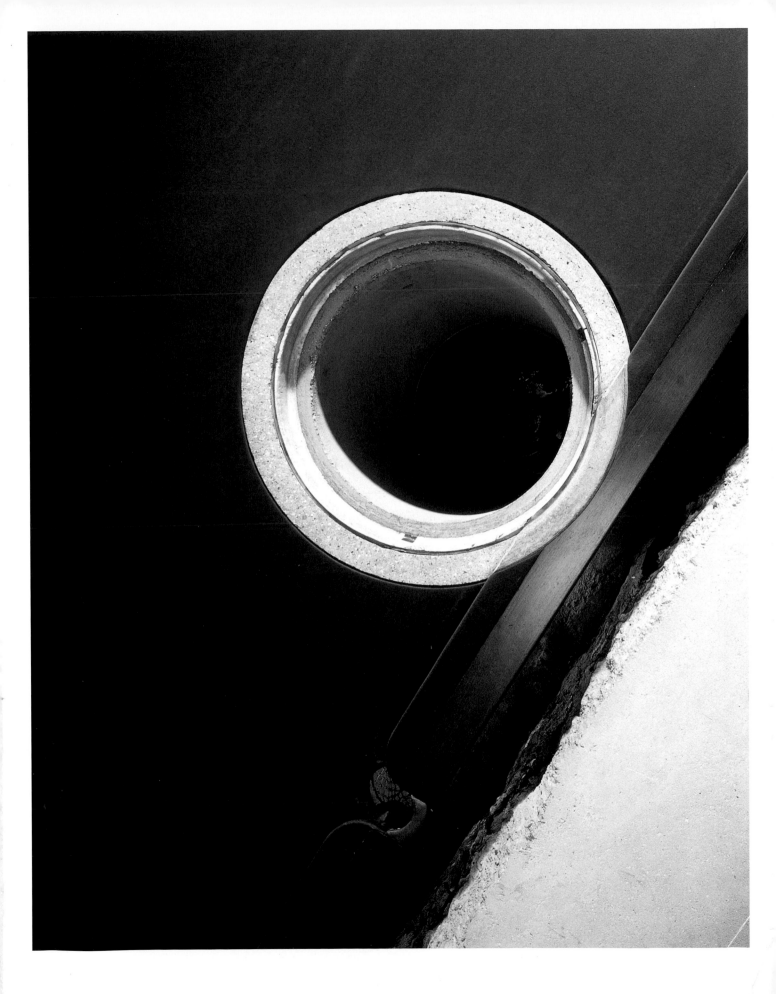

MODERN ARTISTS

First published 2005 by order of the Tate Trustees
by Tate Publishing, a division of Tate Enterprises Ltd,
Millbank, London SW1P 4RG
www.tate.org.uk/publishing
© Tate 2005
British Library Cataloguing in Publication Data
A catalogue record for this book is available from the
British Library
ISBN 1 85437 570 9 (pbk)
Distributed in the United States and Canada by
Harry N. Abrams, Inc., New York
Library of Congress Cataloging in Publication Data
Library of Congress Control Number: 2005923374
Designed by Nick Bell Design
Printed in Singapore

Front cover and previous page:
WATERTABLE (detail)
Overleaf: BUTTERFLY (detail)
Measurements of artworks, where known, are given in
centimetres, height followed by width and depth. Inches are
given in brackets.

Author's acknowledgements
Thanks to Richard Wilson for his continual generosity and
openness that have made writing this book and working
with him in various ways over almost ten years so
pleasurable. Thanks also to Melissa Larner for her skilful
copy editing and of course Lewis Biggs, Judith Severne and
all at Tate Publishing. Last but not least to Tabitha, Issy and
Eva for everything.

Artist's acknowledgements
I wish to thank all the people who made it possible to
assemble the 120 pages of this book. Hats off to Simon
Morrissey for his shaping of words to clarify my motives
plus all those at Tate Publishing who turned the words and
pictures into a volume.

RW

Simon Morrissey

Tate Publishing

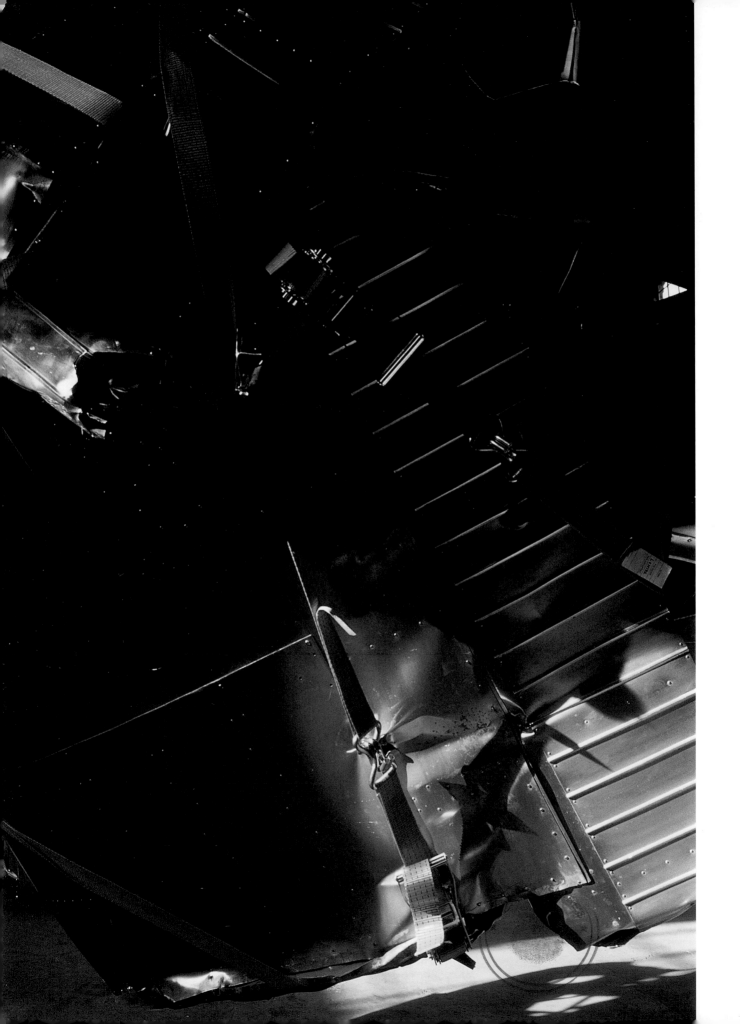

20:50 1987–2003 [1]
Used sump oil, steel, wood, valve tap
Dimensions variable
Installed at Matt's Gallery,
London, 1987
Saatchi Collection, London

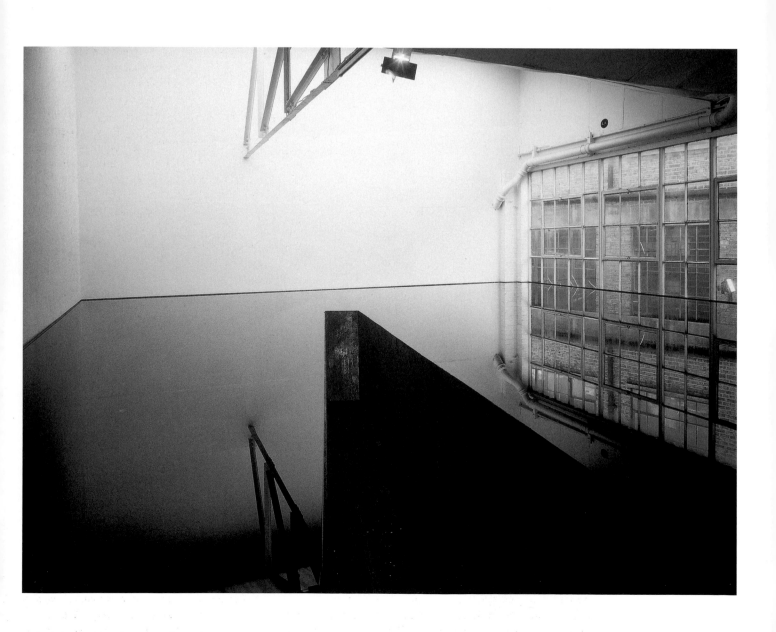

Arthur Wilson
SEACHANGE 2002 [2]
Oil on canvas, mounted on plywood
126 X 40 (49 X 15)
Collection of David Whitaker

But oh, Kitty! Now we come to the passage. You can just see a little peep of the passage in Looking Glass House, if you leave the door of our drawing room wide open: and it's very like our passage as far as you can see, only you know it may be quite different beyond. Oh, Kitty! How nice it would be if we could only get through into Looking Glass House! Let's pretend there's a way of getting through into it somehow, Kitty. Let's pretend the glass has got soft like gauze, so that we can get through.

Lewis Carroll, *Through the Looking Glass* (1871)

This quote from Lewis Carroll's children's classic appeared on the press release for the original exhibition of Richard Wilson's seminal installation *20:50* at Matt's Gallery in 1987. Coming across it during my research for this book I wondered if, apart from alluding to the physical reflective qualities of *20:50*, Wilson had also included it as a form of challenge – a challenge to imagine a different world. This would be perfectly plausible given the way in which his work reorganises the expected behaviour of spaces and things, but the more I thought about it, the more I realised that it was not a challenge to imagine at all. Wilson does not ask us to imagine; instead he makes concrete interventions in the physical world in order to make a different order truly palpable. After almost twenty-five years of continuous physical reconfiguring, one can almost hear his retort to Alice: *No, let's not pretend – let's actually get through.*

If Wilson's work creates one unified impression, it is of the familiar re-informed with a distinctly alternative logic. And as in Carroll's fantasy, the material in which this familiarity is rooted is the fabric of the spaces that immediately surround us. But he does not make works of fiction. His art is not a re-imagining of how things could be; it is a tangible and intense re-negotiation of the built environment in the here and now. It is an exploration of possibility, but one that

Wilson bases in the contingency of the materials that surround us, in a highly concrete form of conjecture:

I don't have a vocabulary of shapes and forms that I create to – I have to go to a real thing. So I'll take a filing cabinet, a billiard table, a swimming pool, a facade or a building and I'll manipulate it in some way – transform it so it no longer functions in the way you expect it to. But I need that initial thing from the real world because I've always been concerned with the way you can alter someone's perception, knock their view of the world off-kilter. And to do that I need to start with something we think we understand.

Wilson's evolving interpretation of the idea of sculpture as a continual attempt to reshape and redirect the environment around him started early on. Born and bred in London, he is firmly rooted in the urban landscape, an environment blatantly fashioned from an imposed human order of planning, architecture, engineering and industry. Yet his family background allowed him to grow up with the idea that this seemingly monolithic landscape was fashioned by the hands of men, and was therefore equally open to revision by them. On his mother's side of the family Wilson is descended from five generations of master builders, whilst on his father's side he is the product of two generations of professional artists. As a child he would spend all day banging nails into wood at the workshop of his grandfather, a builder's merchant in Finsbury Park, north London, whilst a whole gamut of recycling and manufacturing processes went on around him. It was a childhood characterised by a pragmatic attitude to the fulfilling of desires – of using your own skills to manipulate what was around you to become what you wanted:

I remember as a child, anything I ever wanted, my dad would say, 'Alright, I'll make it', even though I'd be thinking, 'Oh no, I don't want that, I want a real bike.' But he'd

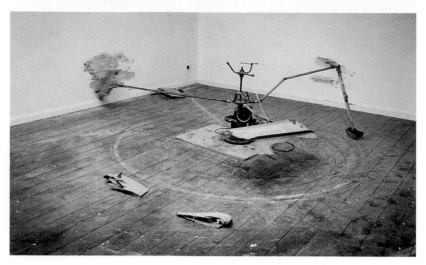

Stephen Cripps
MACHINES & PERFORMANCES
2 April – 4 May 1978 [3]
Daily performances
The Acme Gallery, London

make one out of wood and wire, which now seems quite extraordinary.

Wilson's family not only steeped him in an environment in which making was a way of life, but it also exposed him to an idea that was to be highly important to the evolution of his work – that the genesis of art could come from a peculiarly personal fusion of contexts. After attending art school Wilson's father was conscripted at the end of the Second World War and served as a radar fitter in the RAF. This experience greatly affected his subsequent artistic career, leading him to apply ideas of sine waves and their related mathematical properties to representing the apparent chaos of the sea. This resulted in three-dimensional constructions that he mounted on the wall, whose surfaces were painted with a complex layering of geometry and colour (fig.2). Surrounded by his father's work and reference books, and witnessing the synthesis of ideas into art, Wilson soaked up the way in which his father took the expected reality of the sea and rigorously applied an unexpected logic to it, creating a new and unfamiliar form. When he was taking a foundation course at the London College of Printing and was considering whether to become a graphic designer or a sculptor, his father's advice cemented Wilson's desire to follow in his footsteps: 'Do whatever you're happiest at; you can always earn money.'

Wilson joined the Fine Art department of Hornsey College of Art, London, as a student in 1971, shortly after a new teaching regime had been instituted as a consequence of student protests about antiquated teaching practices. It was the beginning of what has now become the mainstay of fine-art education – the idea of self-directed practice, where students are expected to identify their own interests and the language through which they will explore them. Within a critical framework predominantly centred around the formal qualities of sculpture, Wilson embarked on three years of unfettered experimentation. By the time he arrived on the Masters programme at Reading University, he was beginning to define a territory for himself. Now concentrating on ideas of impermanence in sculpture, he established the work he would continue to make when he left Reading in 1976 and returned to London, where he secured a studio in the sprawling Butler's Wharf warehouse complex south of Tower Bridge. His experimentation was directed towards the idea of sculpture as temporary manifestation, arising from a material's ability to resist the various forces to which he subjected it. He tested the elastic limits of common materials such as wood, wire or cardboard boxes through processes of stress and balance, the work existing only until those limits were reached. Sculptures such as those exhibited in Wilson's first public exhibitions *11 Pieces* 1976, and *12 Pieces* 1978 (both held at Coracle Press Gallery, London) may have endured for weeks, days or only moments, but all operated in a state of precarious balance and eventually destroyed themselves.

Over the next four years Wilson's focus on impermanence led him to experiment with burning sculptures or blowing them up. His interest in these processes was reinforced by his contact with the artist Stephen Cripps, whose studio was next door to Wilson's. Cripps was a year older than Wilson, but would die tragically young in 1982. He was forging a distinctive, anarchic path for himself that involved the transformation of salvaged machine parts, industrial materials and explosives into literally incendiary, often musical performances and auto-destructive kinetic sculptures (fig.3). But Wilson's focus on the transformative, time-based processes of combustion led him back to their place within traditional sculp-

HALO 1986 [4]
Wood, thermal paper, lead
Dimensions variable
Aperto, Venice Biennale, 1986

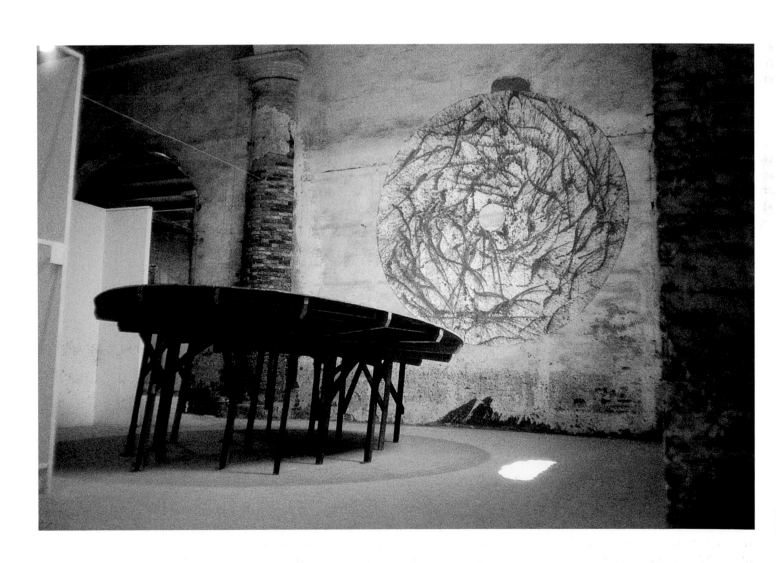

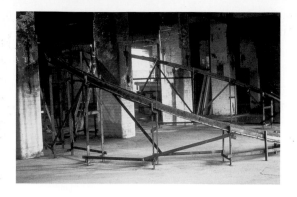

BIG DIPPER 1982 [5]
Wood, sand, aluminium
300 X 210 (118 X 82)
Chisenhale Works, London

BIG DIPPER 1982 [6]
Wood, sand, aluminium
300 X 210 (118 X 82)
Chisenhale Works, London

tural and industrial processes and to the idea of the foundry. In 1982, on the ground floor of Chisenhale Works, which had recently been taken over for conversion into new studios by a group of artists from Butler's Wharf, Wilson made his first significant casting work. *Big Dipper* (figs.5, 6) represented a fundamental development in his thinking about the concept of impermanence within a broader conception of how we expect sculpture to function. The work represented his first attempt to pit suggestions of permanence and impermanence against each other within the creation and exhibition of a work of art. Whereas his previous sculptures had openly signalled their ephemerality through their physical vulnerability or explicitly time-based nature, *Big Dipper* declared itself as a solid, durable entity by way of its materials and method of manufacture. However, it simultaneously underlined the provisional nature of its existence through its relationship to the space in which it was shown. The work consisted of a circular wooden structure angled between the floor and the ceiling, sited amongst three of the fire-damaged support columns on the ground-floor space and enclosing the central column within its bounds. Over a period of days, molten aluminium was poured into a sand mould supported by the structure to form a complete ring around the column, effectively locking the sculpture, its manufacturing structure and the building together. This device gave the sculpture both the appearance of fixedness and the implication of transience, since its very immovability meant that it would have to be destroyed when the exhibition came to an end.

Big Dipper was the first in a series of five in-situ casting works that Wilson made between 1982 and 1986, and the first sculpture to explore the idea of integrating the work with the space in which it was shown. Its aesthetic was arrived at out of its manufacturing processes, and it was built not on the scale of an object, but of the room itself. With these works, Wilson had found the defining factors on which to base his work.

For the metalworking pieces that followed *Big Dipper,* Wilson always enforced the stricture that the work should be made within the exhibition space. Together, these sculptures formed a personal reworking of ideas associated with the American artists who had characterised the expansion of Minimalism into process-based, site-related practices a decade earlier: Richard Serra, Robert Morris and Robert Smithson. Wilson's works combined industrial and traditional sculptural practices with an adherence to process, an aesthetic derived from function, and a re-examination of where art could and should be made. These first installations eroded the notion of the gallery and the studio space as distinct and opposed situations within the production and exhibition of art; the act of casting or hurling molten metal could be executed in the gallery as readily as the studio. And although the aesthetic of the work was derived from the processes used to create it, there was an increasing intimation of mystery within its manifestation; the viewer was left wondering how the object had arrived in the space. *Heatwave* (fig.7), for example, his final in-situ cast, which was made at Ikon Gallery, Birmingham, in 1986, consisted simply of a floating aluminium beam that seemed to have wound itself out into the basement gallery from a starting point near one of the building's soot-blackened support columns.

Halo (fig.4), which Wilson made for the Venice Biennale in 1986, shared a similar spirit to the in-situ casts. The artist threw molten lead from a ladle onto a sheet of heat-sensitive paper cut to fit the tilted platform surface on which it was laid. In this way he

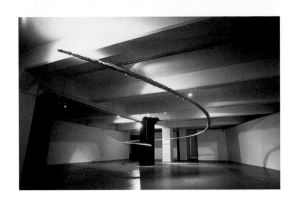

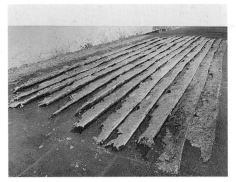

HEATWAVE 1986 [7]
Aluminium, soot and ash
Dimensions variable
Ikon Gallery, Birmingham

Richard Serra
CASTING 1969 [8]
Lead
10 X 765 X 544 (4 X 301 X 214)

produced a drawing of his action – created in the space where it was to be shown, and exhibited alongside the platform – which slowly faded over the duration of the exhibition. When the hot lead hit the paper it produced an Adriatic blue mark – an almost magical process suggesting ideas of alchemy. The work mixed a vocabulary derived from Richard Serra's celebration of the potency of industrial processes (fig.8) with the gestural language of Abstract Expressionism. But Wilson added a new dimension, not present in the casts: he constructed the piece in a way that was replete with formal references to the city in which it was made. The platform resembled a wooden island in the space, supported by a multitude of legs like the pilings that underprop Venice's buildings. Canted on an angle, it seemed to be in the process of sinking, paralleling Venice as a city engaged in a perpetual struggle for preservation.

The evolution of these early process-based works during the mid 1980s placed Wilson in a distinctive, somewhat divergent position, when viewed within the tide of development in British sculpture at the time. His practice was now firmly within installation, but the most visible venue for installation art, the Acme Gallery, had closed in 1981, and this coincided with the first of a number of exhibitions that placed considerable institutional endorsement behind a new generation of object-based British sculptors. Exhibitions such as *Objects & Sculpture,* held at Arnolfini, Bristol, and the ICA, London, in that year, together with *The Sculpture Show,* organised by the Arts Council of Great Britain at the Serpentine and Hayward galleries in London, as well as *Transformations: New Sculpture from Britain* organised by The British Council for the XVII Bienal De São Paulo in Brazil in 1983, brought major acclaim to the artists who were to define British sculpture until the

early 1990s: Tony Cragg, Richard Deacon, Anthony Gormley, Anish Kapoor and Bill Woodrow. As the return to a more traditionally situated object took hold, it fell to spaces that operated outside of such institutionalised trends, such as the Café Gallery, housed in a defunct tea pavilion in Rotherhithe Park, and Matt's Gallery, buried in the midst of a studio block in the East End's London Fields, to provide a context for installation work.

Although Wilson has often referred to *Big Dipper* as his first mature work, it was *Hopperhead,* made for the Café Gallery in 1985, that laid the foundations of his signature practice. Ironically, primary amongst these foundations was the rejection of a core set of materials or processes. Wilson had been looking at the 'anarchitecture' of the American artist Gordon Matta-Clark, who often used the fabric of buildings themselves as his sculptural material, but it was the work of his direct contemporaries, which he had seen at the Acme Gallery, that had solidified his thinking. Amongst a broad programme that encompassed everything from Stephen Cripps's performances to new painting, Wilson had witnessed a number of works that were crystallising his attitude to the function of the exhibition space. Pieces by artists such as Kerry Trengrove, who entombed himself behind a brick wall in the gallery and then tunnelled his way out (fig.9), or *Who Manipulates Who?* 1981 by Wilson's close friend Darrell Viner, which linked an elegantly swaying wooden platform on the ground floor to its dangerously oscillating twin on the top storey by means of four ropes that ran through holes in the floor, confirmed Wilson's decision that the space itself would provide the building blocks out of which the work could be created.

As with the works of Trengrove and Viner, *Hopperhead* (fig.10) both enlisted the physical

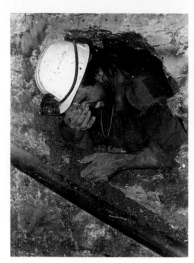

Kerry Trengrove
AN EIGHT DAY PASSAGE [9]
Image from the end of
installation/performance at the
Acme Gallery, London,
25 October – 1 November 1977

elements of the site in its creation and brought external elements to it. Unlike their works however, and unlike Matta-Clark's surgical interventions, it also enlisted the site's contextual elements. In this way the site was not simply transposed from container for the work to fabric of the work, but also from container for the work to generator of the work. The Café Gallery was housed in a small building in Southwark Park that had previously provided refreshments to the users of the swimming pool alongside it. Wilson's response to this context was elegant in its circularity: he restated the building's relationship to the pool it used to serve by physically emptying the pool into the gallery. Over the duration of the exhibition 21,000 gallons of water were pumped in a thirty-three-foot pressurised jet from the swimming pool into the gallery through a hole in a window previously used as a serving hatch. The visitor's first impression of the work was a sound like white noise or a continuously vibrating cymbal as the water landed noisily in a metal hopper inside the gallery. The eye was then drawn along the trajectory of the jet of water in search of its source: a pump coming from the pool. The fact that one's encounter with *Hopperhead* took place in reverse – with effect acting as a signpost for cause – was particularly fitting since the work was an essay in the reversal of expected relationships. These reversals were both formal and structural. Where liquid refreshment had once gone out, water now came in, bringing what should be outside inside, making a body of water that was once stable, dynamic, and causing the pool to serve what had previously served it. Thus Wilson made his audience question where his work began and the site ended – was the work the hopper of the title? The jet of water? The former café? The swimming pool? Or all of these things?

Hopperhead signified the abandonment of signature processes and materials for a prioritising of engagement with the specific context of the site and a commitment to formulating new and unusual experiences out of the familiar. The work was truly site-specific and was thus of considerable significance to the long-term development of Wilson's artistic direction. More important in terms of his immediate career, however, was the relationship he forged with the newly established Matt's Gallery when he created the in-situ cast *Sheer Fluke* there in 1985. Although this work was not particularly significant in itself, Matt's Gallery was to provide the context for the piece that, in only two years' time, would elevate Wilson to international acclaim.

HOPPERHEAD 1985 [10]
Pump, swimming-pool water, steel,
rubber hose, copper tubing
Dimensions variable
Café Gallery, London

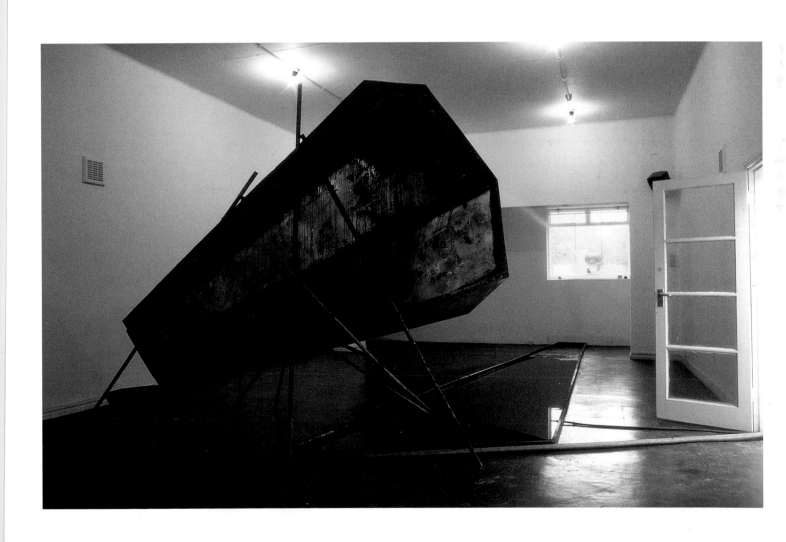

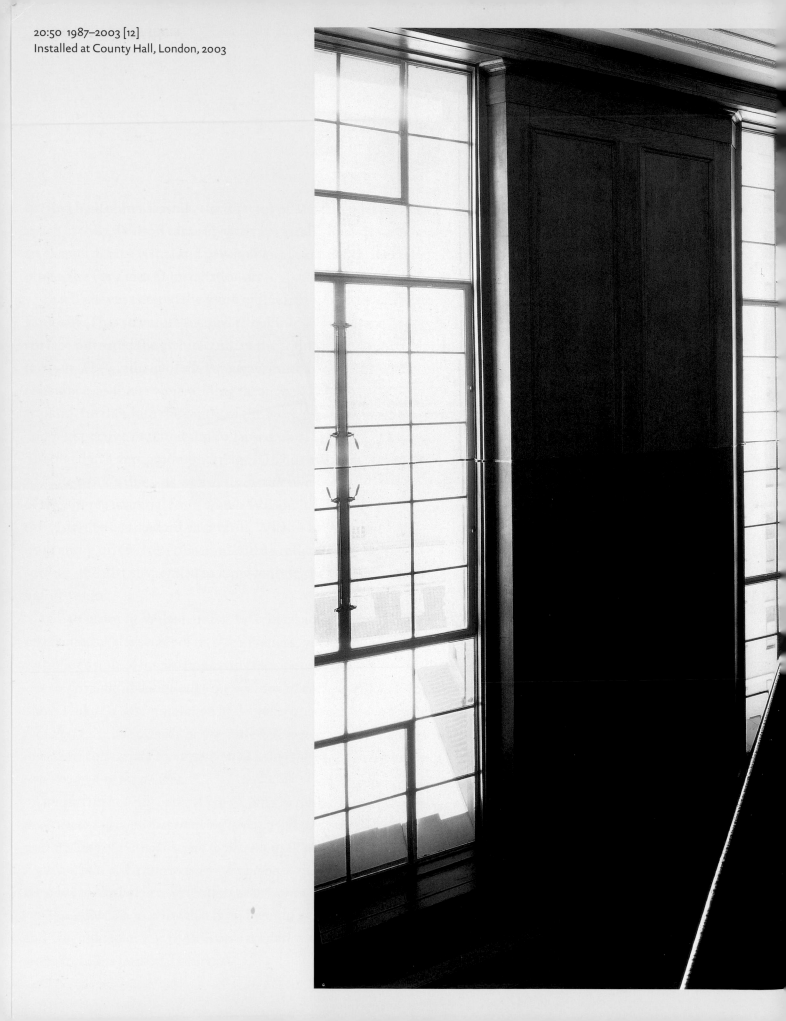

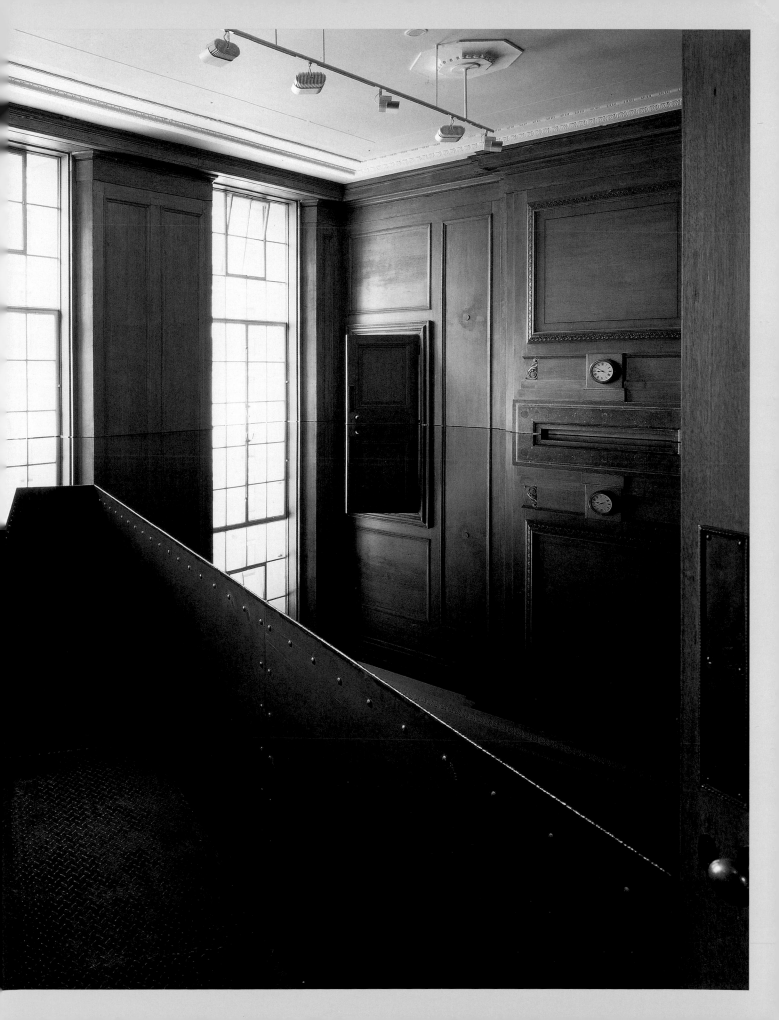

The oil became part of the piece because I had a drum of the stuff I'd used for annealing steel sitting in my studio. I'd been meaning to get rid of it but had just never got round to it. The drum didn't have a lid and in the meantime all sorts of rubbish had accumulated around it. But I'd always loved the way that in amongst all these bits of wood and junk there was this void, this perfect reflection. That was the final piece of the jigsaw. Because I knew the oil had an extremely reflective surface, I knew I could create a horizontal plane that should divide the room but instead would engulf you because the oil would perfectly mirror its surroundings.

Thus *20:50* referred explicitly to the gallery in which it was situated, mirroring its details and defined by its physical boundaries. Because of this, it has repeatedly been described by critics as site-specific, but although it had been made *for* Matt's Gallery (fig.1), unlike *Hopperhead* it was not *about* its location. This was quickly demonstrated by its agile transferability. Purchased by Charles Saatchi soon after it was shown at Matt's Gallery, *20:50* was remade within distinctly different surroundings but to equally compelling effect for *Art of Our Time,* which showcased Saatchi's growing collection of contemporary art at the Royal Scottish Academy, Edinburgh, that same year. By the time Wilson was awarded the prestigious DAAD residency programme in Berlin in 1993 it had been remade twice more, for Saatchi's gallery in Boundary Road, north London, and at the Mito Art Tower in Japan. The inadequacy of the critical language available to describe the work was noted by James Roberts, writing in Wilson's DAAD catalogue, when he described *20:50* as 'unusual in that it is a site-specific piece that is able to specify to almost any site'.[1] The work has continued performing its chameleon-like illusion in venues across the world (fig.13), most recently being remade for Saatchi's new gallery housed in London's County Hall in 2003 (fig.12). Here, Wilson chose to install the work in a room ostentatiously clad in oak panelling. The room is the antithesis of almost every space in which the work has been previously installed, yet the effect remains unchanged, underlining the fact that *20:50* is best understood as a set of conditions applied to a given space rather than a work that is *about* that space.

The need to make this distinction between whether a work is made *for* a space or *about* it, whether it relates to its site, is physically dependent on it, or is exclusively site-specific, is vital to any detailed understanding of Wilson's work. As the artist himself has said:

20:50 isn't site-specific at all; if anything it's the complete opposite. If I was going to have to call it something I suppose it would be a 'conceptual installation'. 20:50 is essentially an idea. It can be applied to any internal space and in each space it will be radically

different in appearance – because it will reflect that specific space and adapt to that space's physical parameters – but fundamentally on the level of function, materials and meaning, it's always exactly the same.

But it also remains consistently elusive. The work is essentially comprised of a single material, deployed to mirror a given space. Yet it is no more *about* the room that houses it than it is about oil. Indeed, the work is not *about* anything at all. Instead *20:50* is essentially experiential, and as such its meaning is the disorientating effect of being enveloped within its symmetrical visual plane. To extend the analogy with Lewis Carroll: it is not a work about Wonderland, it *is* Wonderland.

[1] James Roberts, 'Richard Wilson', in *Richard Wilson,* exh. cat., DAAD, Berlin 1993.

20:50 1987–2003 [13]
Installed at Australian
National Gallery,
Canberra, 1996

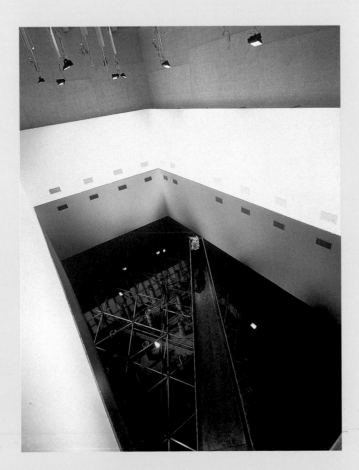

BOW GAMELAN ENSEMBLE
1983–91 [14]
Multimedia performance band

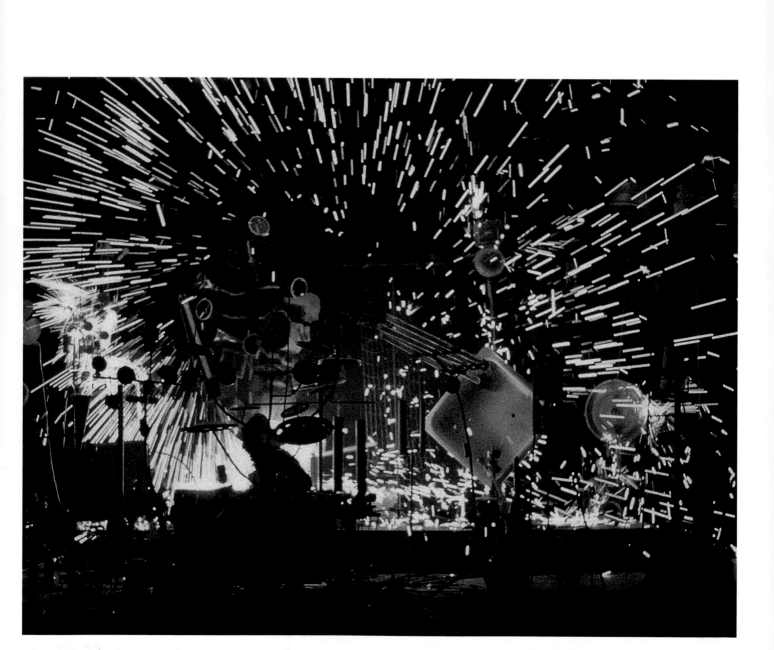

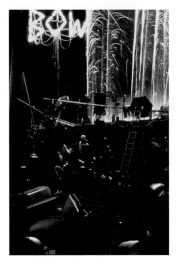

BOW GAMELAN ENSEMBLE
1983–91 [15]
Multimedia performance band

NO FORMULAS

Hopperhead and *20:50*, made within the space of only two years, represent two distinct modes of practice within an expanded sculptural territory, yet each was deployed with equal emphasis and with no sense of contradiction. This approach characterises the way in which the artist's body of work was to evolve.

Now that Wilson had firmly established for himself that experimentation within a chosen territory was at the centre of his practice, he increasingly came to view his casting works as formulaic, and the idea of adherence to any one dictum was steadily becoming anathema to him. Thus the object to be defined was the territory in which he would work, not the way in which he would work within it. In identifying the transformation of the exhibition space as the territory, he ensured that his work would be positioned along various points on a trajectory through this field rather than at a fixed position within it.

Yet this is not to say that there were no dominant characteristics that recurred within Wilson's installations. References both to the traditional formal concerns of sculpture and to the Minimalist adherence to the inherent quality and function of materials provided a continuity to the way in which Wilson approached the space. In these terms, whereas *Hopperhead* had dealt with the idea of the displacement of a mass of material into a line, *20:50* had drawn on the relationship between surface and volume. The work's material simplicity and matter-of-fact treatment of materials was even more reminiscent of Minimalist strategies than *Hopperhead*. Through the conception of *20:50* Wilson also came to realise that applying a similar directness to his decision-making process was essential to achieving the tone he wanted for his works:

In the end it was just like, 'Fuck it! Just flood the whole room! Get rid of all the unnecessary considerations and just make it function. Let's just make a tank in the room and fill it – make the tank the shape of the room, don't design anything.' The only question then was accessing the reflection, and the approach here was the same – 'Just cut a slice out of it so you can walk in.'

Wilson was becoming increasingly confident, giving his magpie tendencies full reign to glean ideas from diverse sources and then adapting them to his own ends. The material strategies of Minimalism were thus deployed in the service of an end that many would not readily associate with the genre: the creation of spectacle. He had fostered a fascination with spectacle since an early age, but the spectacle that captured his interest was not the emerging contemporary spectacle of consumer capitalism, the media or celebrity, but an idea of physical spectacle that he has described as *sort of a century out of date*. This was the Victorian idea of spectacle, of a grand entertainment or an organised public display of objects of curiosity and admiration. He was captivated by the feats of Victorian engineers such as Isambard Kingdom Brunel and their unquenchable thirst to build bigger, better and faster than before. He was also interested in how their public received these endeavours during a period marked not by the cynicism so prevalent in contemporary society but by an apparently genuine awe in the face of the new.

This interest in the creation and reception of spectacle was particularly evident in the performances of the Bow Gamelan Ensemble in which Wilson participated between 1983 and 1991 (figs.14, 15). The percussion performance collective derived its name from Indonesian metallophone groups, loosely transcribed to the area of London in which Wilson and his fellow co-founders (percussionist Paul Burwell and performance artist Anne Bean) lived and worked.

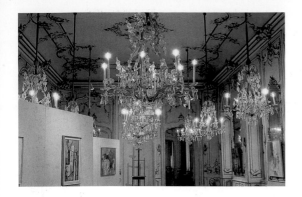

UP A BLIND ALLEY 1987 [16]
Seven motorised, gilded blind person's
sticks, lead, motors
Dimensions variable
Trigon Biennale, Graz

UP A BLIND ALLEY 1987 [17]
Seven motorised, gilded blind
person's sticks, lead, motors
Dimensions variable
Trigon Biennale, Graz

Taking up the mantel of their close friend and contemporary Stephen Cripps, the group specialised in performances that exploited the 'natural acoustics' of unique instruments constructed from salvaged components such as scrap metal, glass and electric motors, industrial whistles, horns and warning systems, and tools such as angle-grinders and blow-torches, along with pyrotechnic displays, to create intense spectacles of fire, light and noise.

Whereas Bow Gamelan derived its inspiration directly from what Wilson has termed the 'rather romantic quality of the Victorian industry associated with the Thames: steam, fire, machinery clunking and churning, chains banging, arc welders working', the idea of spectacle in his installations was to take a much more subtle form. Wilson's decision to ally his interest in spectacle with his decision to focus on the temporary transformation of spaces was made concrete through his reflection on the observations made by Gordon Matta-Clark on the contemporary gaze:

Matta-Clark characterised the contemporary gaze as a snatched look, a snapshot look. He argued that under the pressure of the structures of contemporary society – things like high-speed travel, multi-channel television and the intense proliferation of images – we've lost our ability to look at things in a sustained manner. Therefore he thought that to compete, art had to take the familiar and make it spectacular, because through being spectacular you seize the audience's attention for long enough for them to want to unpack that initial image and examine the story behind it.

The two years following 20:50's acclaimed debut at Matt's Gallery marked a new intensity in Wilson's career, bringing numerous invitations to create works. But if the installations made between 1987 and 1989 did not locate the spectacular in similar territory to the overt onslaughts of the Bow Gamelan Ensemble, neither did they follow Matta-Clark's quasi-destructive interventions on an architectural scale. Instead, taking his cue from the effect of 20:50, Wilson filtered the idea of spectacle through the notion of the curious and arresting event, the viewer's personal encounter with unexpected sensations.

Installations such as *One Piece at a Time* 1987, *Up a Blind Alley* 1987, *Leading Lights* 1989 and *Sea Level* 1989, introduced interventions based on sound, light and heat to alter the viewer's experience of the exhibition space. These were so subtly deployed that the first impression was often of an empty room. This was the case with *Up a Blind Alley*, for example, Wilson's contribution to the Trigon Biennale, in Graz, Austria. Confronted with an opulent room in a baroque building, Wilson had realised that anything he sited there would have to compete for attention with the stucco work, friezes, chandeliers and baroque furniture. He therefore decided to take this idea of the audience searching the room to locate his work to an exaggerated extreme, leaving the interior completely unaltered (fig.16). Instead, he attached seven motorised blind person's canes to the exterior wall of the building, which repeatedly tapped on the wall and window of the room (fig.17). The experience of the work became one of scouring the detail of the interior in the vain attempt to locate the source of the persistent tapping, which seemed to emanate from the very fabric of the room.

For *Leading Lights*, made for the Kunsthallen Brandts Klaederfabrik, a former cloth mill in Odense, Denmark, Wilson again added nothing to the space. Instead he simply manipulated one element of the available fabric to uncomfortable effect. The vast room was flanked with evenly spaced windows, divided by regular rows of slim circular columns and

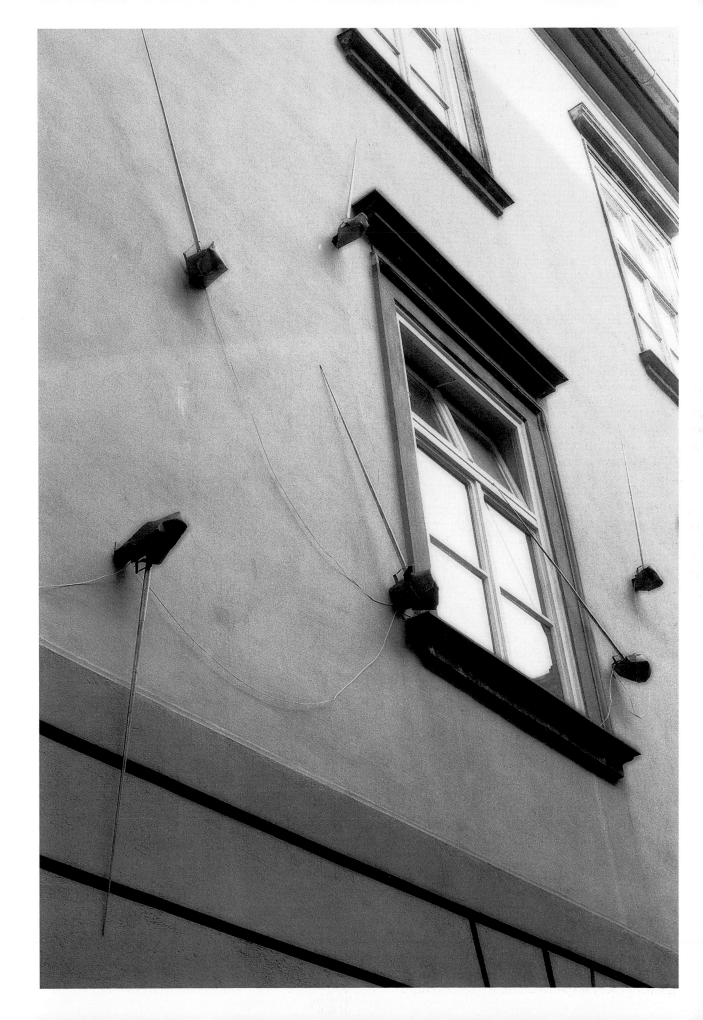

LEADING LIGHTS 1989 [18]
Eighty-four light bulbs, electric cable
and fittings
1900 x 220 (748 x 866)
Kunsthallen Brandts Klaederfabrik,
Odense

LEADING LIGHTS 1989 [19]
Eighty-four light bulbs, electric cable
and fittings
1900 x 220 (748 x 866)
Kunsthallen Brandts Klaederfabrik,
Odense

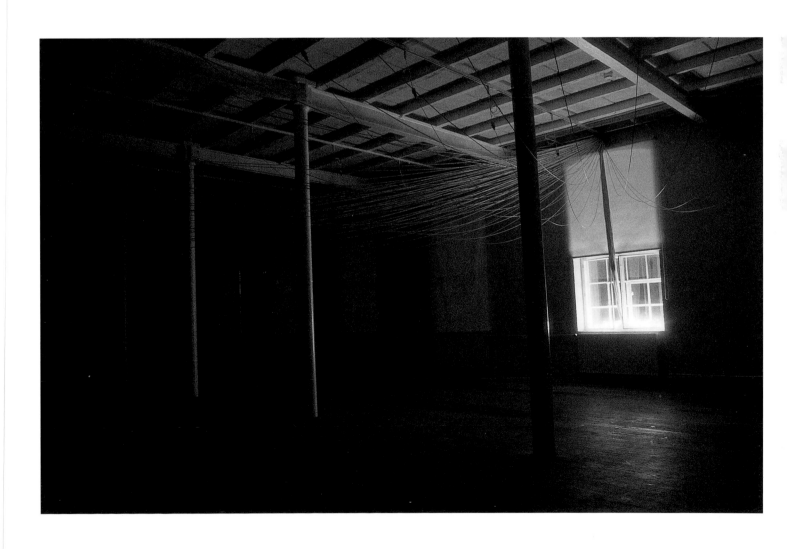

SEA LEVEL 1989 [22]
Galvanised steel grille, steel
and gas-fired space heater
1900 X 2200 (748 X 866)
Arnolfini, Bristol

ONE PIECE AT A TIME 1987

ONE PIECE AT A TIME
1987 [23, and 24, 25 overleaf]
1200 car parts, string,
motors, steel, wood,
closed-circuit television
2930 X 1220 X 910
(1153 X 480 X 358)
South Tower, Tyne Bridge,
Gateshead

Created only months after *20:50*, *One Piece at a Time* reasserted the breadth of positions that Wilson was adopting in his engagement with a space, whilst at the same time illustrating the new expanded territory within which artists were being invited to work.

The installation was made for the South Tower of the Tyne Bridge between Newcastle and Gateshead at the invitation of TSWA. Instigated by Jonathan Harvey, previously the director of the Acme Gallery, TSWA was a commissioning agency that was leading the drive to create opportunities for artists to make work outside of the gallery system in Britain. Like the Munster Sculpture Project in Germany and Chambres d'Amis in Gent, Belgium, TSWA's ambition was to prioritise the creation and experience of art in public spaces over the neutrality of the traditional gallery.

In their introduction to the catalogue for TSWA 3D, the organisers highlighted the new climate in which work such as Wilson's was being situated:

Not long ago, artists had a very good idea where they could place art and people knew where they could find it. Now the possibilities for artists have become at the same time more expansive and more demanding. Factories and forests, slaughterhouses and opera houses, churches, psychiatric hospitals and private homes, all have recently been opened up as spaces which they activate and make anew … TSWA 3D exists between an idea of place and an idea of space. The places exist: they are not normally perceived as spaces for art … It is the desire of the artists in TSWA 3D to transform these places through the collaboration of art into something more open and less certain.[1]

This last sentence could easily operate as a description of Wilson's agenda in general. *One Piece at a Time* bore similarities to his other installations of the period in that the intervention impinged on the senses and was designed to present an unexpected experience within its host space. However, the intertwining resonances of the site led him to produce a work that was not only intricately wound up with the physicality of the site but also with the history of its geographical location and the space's metaphorical potential within wider socio-political discussions:

The first thing that struck me when I visited the site was its sense of redundancy. The area around the bridge was rather a forlorn place that had lost any sense of the past activity that would have dominated the area. The Tyne was a major shipbuilding area and it would have been completely alive with the metallic sounds of that industry but it was now silent.

But once inside the Tower itself there was this thunderous sound. The two towers were positioned beneath the expansion plates for the bridge, and the sound of the traffic going over the plates on the road above – which is the main road from London to Edinburgh – made this

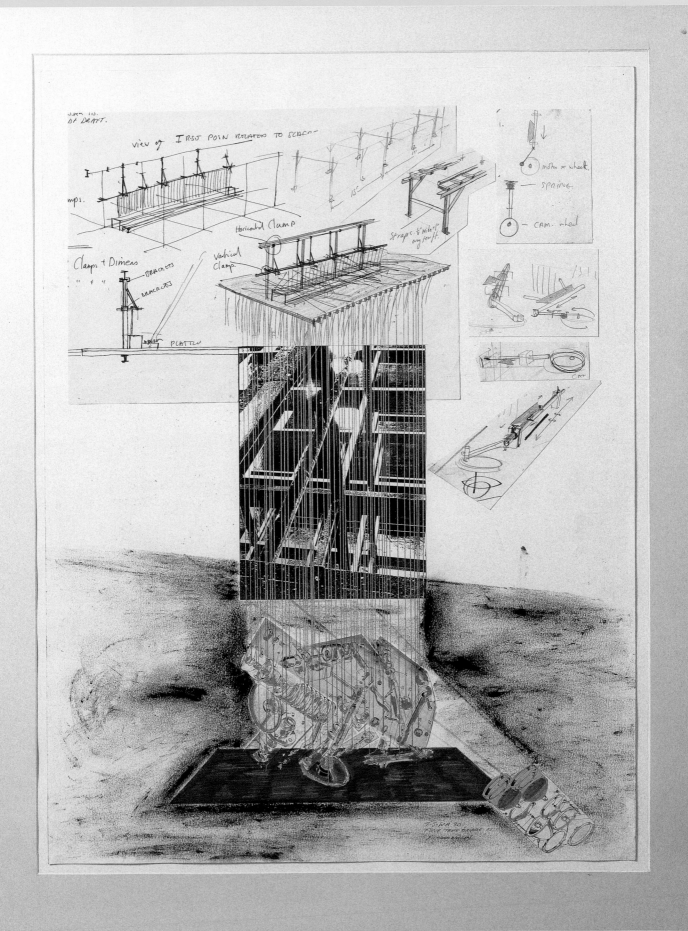

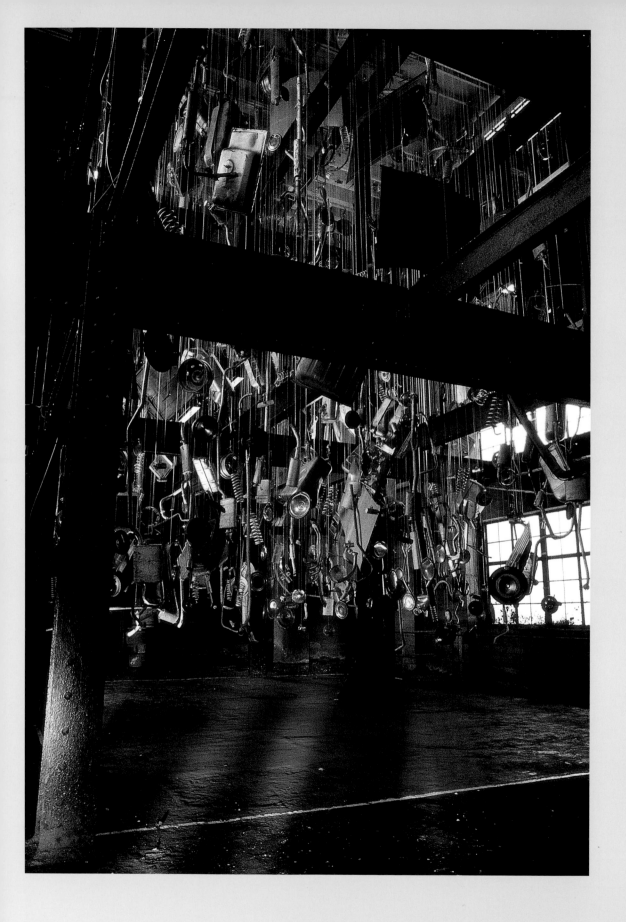

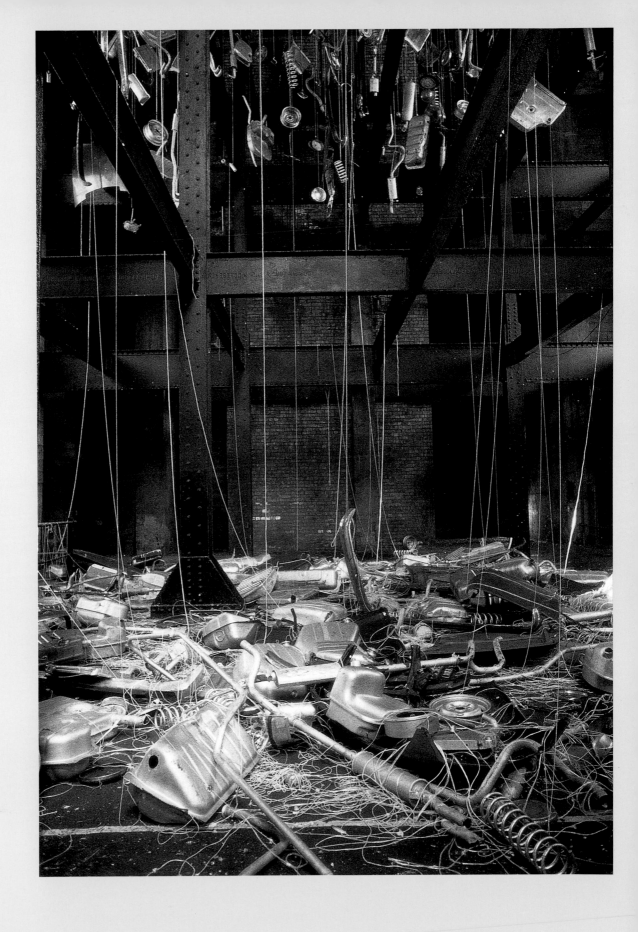

quite extraordinary *cur-dang-cur-dang-cur-dang-cur-dang* resonate throughout the space. There was this sound all the time and that was either going to hinder what I did or I had to allow it to become part of the work. And with the sound came the idea of movement: the movement of the cars, the movement of the river and then a vertical movement very particular to the tower – the streaks of pigeon droppings that had built up on the walls over the years.

The tower was a cavernous space, very wide, very long but extraordinarily high. I think it measured something like 40 x 50 x 125 feet and so it became obvious that I had to think about the space between ground and ceiling, up to where the road was. Using the height of the space was the last piece of the jigsaw. Then it was like, OK: loss of industry, loss of sound, traffic, cars, new sound in this space that was like a bell tower. And bell towers have clarions in them – clusters of bells. I realised I wanted to make my own clarion to produce a cacophony of sound in the space. I love Johnny Cash, and his song 'One Piece at a Time', about a Detroit car assembly line worker who steals parts to build a car at home, brought it all together into the idea of making a huge timing mechanism by suspending 1,200 car parts in the ceiling then cutting them down one by one over the duration of the show.

I got all sorts of parts – bits of engine, springs, doors, bumpers, hubcaps, windscreen wipers, everything – from a scrap yard called Journey's End just outside Newcastle. The parts were then all suspended on plastic wires 85 feet up in the tower with the strings brought together like a vertical fence in the middle of the space, where a cutting mechanism I built, which ran along on a pulley system, cut down forty parts a day.

The sound of the car parts crashing to the ground was recorded on two video decks – because it was the tape that could hold the most sound at the time – and played back the next day alongside the live sound of that day's forty parts falling. As the piece went on there was this increasing accumulation of real and recorded sound onto the tapes so that by the last day there was this assault, this cacophony of sound crashing and all sorts of incidental build up of debris from the moving cars and the static hissing of the tape etc. The last forty car parts finished falling within 1 hour of the end of the exhibition.

On one level *One Piece at a Time* was an essay in the compression of time – individual, isolated events being fashioned into a dense fabric of artificially orchestrated simultaneity. The fact that the work was partly made up of recorded memories adds to this temporal dimension and is analogous to the layering of recorded history. On another level one could see this orchestration of obsolete objects as a compelling work about physical disintegration. The confluence of these factors led some commentators to interpret the work as a direct comment on the social environment in which it was situated.

Writing about Wilson's installation at the time, *The Times* art critic Richard Cork said:

The sense of unending calamity does not seem misplaced in this particular context for he can hardly be unaware that the event is being staged in a city where unemployment has claimed a grievous number of victims in recent years ... Wilson has made a work wide enough in its implications to encompass the tragedy of a society that severs people from their former sources of livelihood. [2]

[1] James Lingwood, Tony Foster and Jonathan Harvey, 'Introduction', in *TWSA 3D*, exh. cat., 1987, p.5.
[2] Richard Cork, 'Beyond the Tyranny of the Predictable', in *TSWA 3D*, exh. cat., 1987, p.12.

ONE PIECE AT A TIME
1987 [26]
1200 car parts, string,
motors, steel, wood,
closed-circuit television
2930 X 1220 X 910
(1153 X 480 X 358)
South Tower, Tyne Bridge,
Gateshead

SHE CAME IN THROUGH THE
BATHROOM WINDOW 1989 [27]
Gallery window, steel, softboard,
PVC material, tungsten-halogen
floodlights
180 x 490 x 430
(71 3/4 x 193 x 169 1/4)
Matt's Gallery, London

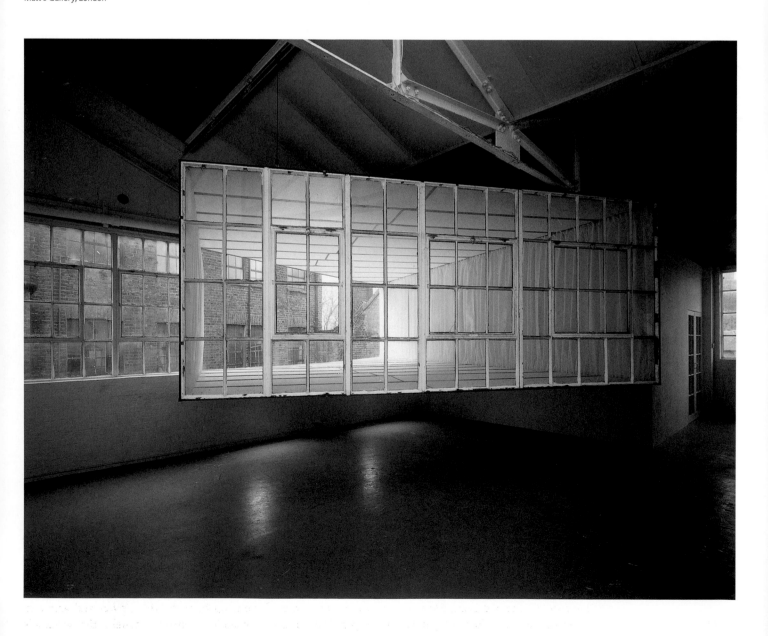

WATERTABLE 1994 [28]
Full-size billiard table, concrete pipe,
ground water and electrics
370 X 210 X 400
(145 $\frac{1}{2}$ X 82 $\frac{1}{2}$ X 157 $\frac{1}{2}$)
Matt's Gallery, London

FULL OF HOLES AND CUTTING CORNERS

3

The installations of the late 1980s defined broad parameters for Wilson's installations. They set out a territory between the site-specific and the transferable installation, between an engagement with the purely physical characteristics of a space and the resonances of its broader historical and social contexts. However, within this territory they had one tendency in common: they were all singular additions to a space. 'Additions' is perhaps a more precise term than 'interventions' in the sense that elements from outside the space were brought to bear to alter the expected behaviour of that space. Any physical rearrangement of the spaces within which the artist had been working was located at the periphery of what could be termed their actual fabric, such as the alteration of the lighting in *Leading Lights*.

However, Wilson's ongoing project to challenge assumptions about and apprehension of space, structure and sculpture meant that he would inevitably begin to enlist the architectural components of the site. The economical means by which artists such as Gordon Matta-Clark and Chris Burden had transformed spaces by removing sections of floors and walls had always inspired the economy of Wilson's own vocabulary. But increasingly their example was reinforcing Wilson's conviction that 'I could go further and choreograph the architecture itself to provide the experience of the work'.

Wilson's continuing relationship with Matt's Gallery was to prove vital in providing him with the opportunity to do just that in 1989. Taking its title from a song as *One Piece at a Time* had done, *She came in through the bathroom window* (fig.27) could not have been more different from the Tyneside installation. Although arguably as specific to its site as *One Piece at a Time* had been, *She came in through the bathroom window* focused purely on the physical fabric of the gallery. Its genesis was influenced by *20:50*, just as that work had been influenced by its predecessor *Sheer Fluke*. One of the most arresting features of *20:50* at Matt's Gallery had been the reflection of the gallery windows and the urban landscape beyond. Wilson now decided to make the window itself the subject of his new work. A sixteen-foot section of window was removed from its housing and brought into the gallery space so that the space enclosed between its new position and its original one occupied the greatest part of the gallery. It was hung at a displaced angle to its normal orientation and attached at each side to the opening in the wall with white PVC. The fact that this new container was allowed to protrude out into exterior space meant that the work acted both as obstacle and funnel, restricting the movement of those in the space, but bringing the outside in. Discussing the piece in 1995 with Jeremy Till for the magazine *Artifice*, Wilson said:

Where the window was shunted in across the room it left very little room for people to manoeuvre. The audience was literally given only certain spots in which to stand. Because it was so imposing in the room, it was very difficult to take in the overall piece of work in one glance. There is the sense with a lot of my pieces of conditioning the body to have to perform in order to find out what the work is about. The person tends to be enclosed by the sculpture, or oscillates between two points of a room, so as to come to terms with what I've actually done to the space.[1]

Despite the simplicity of Wilson's intervention *She came in through the bathroom window* engineered a snowballing series of sculptural inversions: edge became centre, plane became mass, exterior became interior and container became subject. These inversions extended from the properties of the object into the relationship between the viewer and artwork. Pushed dynamically into the gallery, the window's

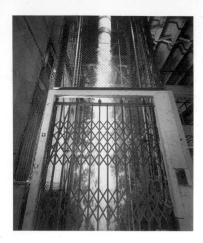

Darrell Viner
SECURE [29]
Water, pipework, liftshaft
Old Millbay Laundry, Plymouth

ALL MOD CONS 1990[30]
Wood, steel tube, steel
Dimensions variable
Edge 90, Edge, Newcastle upon Tyne

new mass gave it dominion over the audience and turned its normal role as an impassive conduit for the viewer's gaze on its head, the window instead becoming a huge lens engaged in the process of scrutinising those placed before it.

The displacement of existing elements of spaces flowed through the works made in subsequent years. For *All Mod Cons* 1990 – which was made in Newcastle-upon-Tyne as part of *Edge*, an exhibition of new works in non-gallery sites – Wilson again confused the certainties of inside and outside (figs.30, 31). The same year, his friend Darrell Viner made the kinetic installation *Secure,* which manipulated the sprinkler system and burglar-alarm motion sensors of an old laundry building to induce a palpable sense of bodily disorientation and physical insecurity (fig.29). *All Mod Cons* similarly destabilised the security we normally ascribe to the floor beneath our feet. On the top storey of a derelict warehouse building scheduled for conversion into flats, Wilson removed a section of floorboards in front of the loading-bay doors. A new replacement floor was then hung, which rather than spanning the joists like a normal floor, adhered strictly to the topology of the space revealed by removing the previous one, rendering it unusable. Like the container delineated by the angle of the displaced window in *She came in through the bathroom window*, the floor protruded past its original bounds to terminate outside the building. Approaching from inside the building, the viewer first encountered what could more accurately be described as a freshly clad hole than anything that would conform to the idea of a floor, but the intrepid could mount this construct as it neared the open loading bay doors and venture out onto the new, sickeningly sloped balcony, which protruded precariously over the abandoned waste-ground below. The

ALL MOD CONS 1990[31]
Wood, steel tube, steel
Dimensions variable
Edge 90, Edge, Newcastle upon Tyne

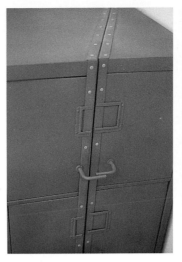

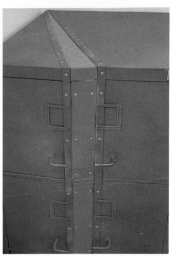

dysfunctional nature of *All Mod Cons* not only explicitly countered the expected function of floor and balcony, but also implicitly undermined the idea of 'improvement' that is assumed in the act of replacement. Within the context of the gentrification process represented by the warehouse, there is strong potential to interpret the work as a sardonic swipe at the rhetoric of 'progress' so readily deployed by developers.

Not too clear on the viewfinder, made for the IXth Sydney Biennale in 1992, displaced a pair of steel firedoors into the centre of a room, where they were suspended like huge book-pages (fig.32). However, unlike *All Mod Cons* the ideas of displacement within the work resided more in the mind of the viewer than in the physical experience of the piece. A text was etched onto the doors describing the space in which the work was shown, but the description had been based on video footage made to document the space that had been too dark for Wilson to decipher. Harshly illuminated by a single floodlight, the etched text reflected the light in such a way as to make it almost illegible, and the task of reading it was disproportionately difficult in relation to the poor rewards offered by the faltering description of a space that viewers could already apprehend for themselves. Although the inclusion of text in this work may appear to be a departure, it illustrates how Wilson's response to a given site is often influenced by contingent factors. The lack of adequate visual documentation presented him with the opportunity to stress the importance he continually attributes to the viewer's physical exploration of both artwork and space, but in this case through emphasising the inadequacy of a description in direct contrast to the actuality of what is being described.

Wilson had broadened his parameters into the realm of alteration – now he could alter, add, or subtract whatever he chose. This freedom to create the relationship between space and sculpture led him to challenge his own preconceptions of where architecture as an idea begins and ends. Did architecture only encompass permanent buildings? Weren't sheds, chalets, glasshouses or even caravans a type of architecture? Was a door or a radiator an object or an architectural fitting? Did a filing cabinet or a shelf have any meaning outside of its relationship to an interior?

A group of works made between 1991 and 1996 began to test these questions, again concentrating primarily on the idea of destabilising the distinction between what the viewer would expect to view as object and container, sculpture and gallery. *Lodger* 1991 was an inverted self-assembly wooden summerhouse, which sat on one of its gables within the limited confines of Galleria Valeria Belvedere, Milan (fig.35). It was cut to follow the architecture of the rooms in which it was exhibited, with an impenetrable negative third space colonising the interior. For *Return to Sender* 1991, Wilson removed a radiator and the mullions from the window above from the exterior wall of Galerie de L'Ancienne Poste, Calais, and relocated them to the centre of the room (fig.36). The newly placed object was then physically joined to its original location with copper pipes and plastic twinwall sheeting, thus allowing them to perform their original functions of heating the room and supporting the glass in the window whilst also operating as an object of contemplation. *Cutting Corners* 1995, again made for GalleriaValeria Belvedere, consisted simply of two identical filing cabinets placed in opposite corners of the room (figs.33, 34). The gallery, however, was not square, one corner being an obtuse angle and the other acute. A section was therefore

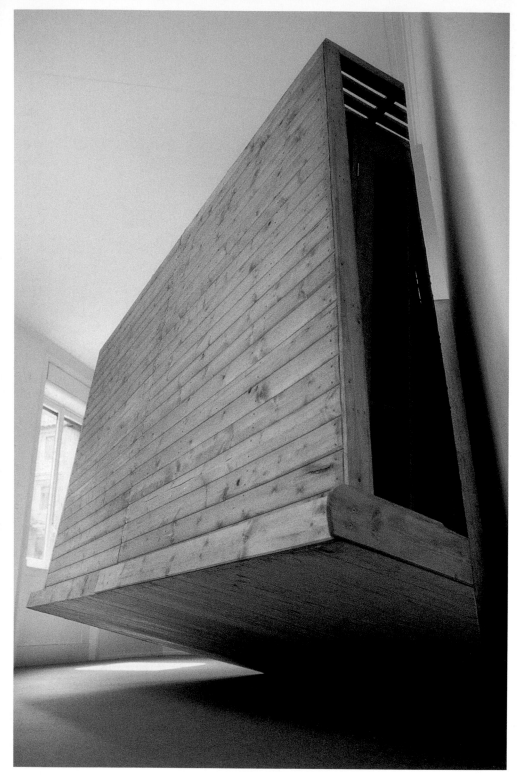

LODGER 1991 [35]
Wooden Chalet, galvanised steel
Dimensions variable
Galleria Valeria Belvedere, Milan

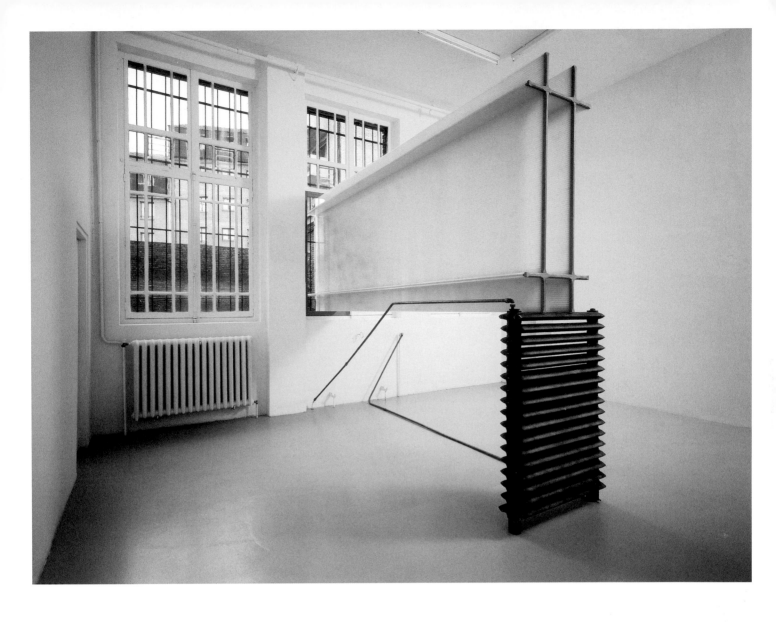

RETURN TO SENDER 1992 [36]
Radiator, copper piping, section of
window, twin-wall plastic sheeting
Dimensions variable
Galerie de l'Ancienne Poste, Calais

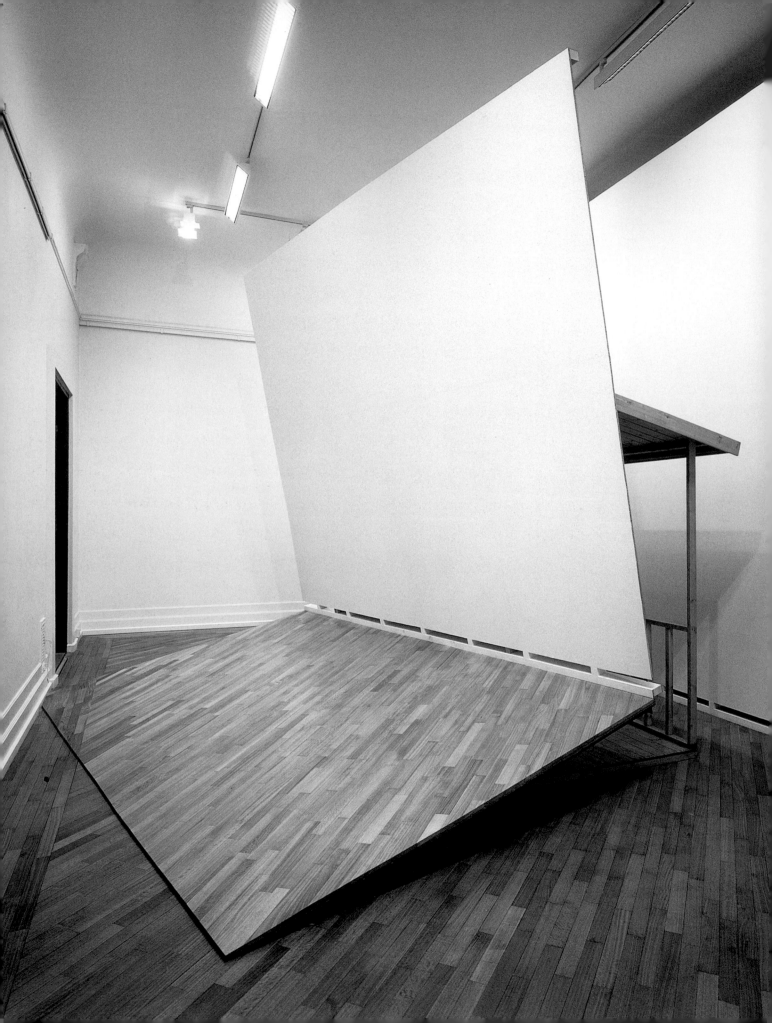

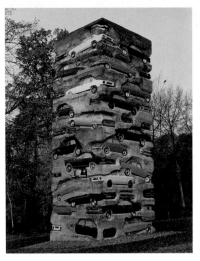

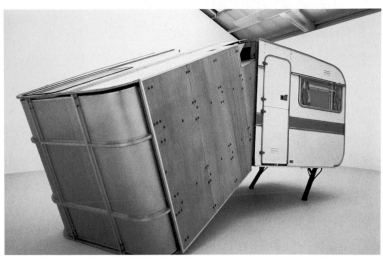

ELBOW ROOM 1993 [37]
Wooden chalet, steel,
wooden flooring
Dimensions variable
On Siat, Museet for
Samtidskunst, Oslo

Arman
LONG TERM PARKING 1982 [38]
Sixty cars in concrete
1981 x 610 x 610 (780 x 240 x 240)
Jouy-en-Josas

FACE LIFT 1991 [39]
Wood, steel, aluminium
300 x 240 x 550
(118 x 94 x 216) approx
Saatchi Gallery, London
Arts Council Collection

removed from one cabinet and inserted into its part-ner, increasing the exterior angle of one cabinet whilst reducing the other. Once the altered cabinets had been riveted back together they fitted the opposing angles of the room exactly, but were rendered unus-able, directly illustrating the drawbacks in fetishising the pursuit of order.

Other works were not even physically integrated with their host spaces but were still explicitly designed to upset the viewer's spatial expectations. In *Elbow Room* 1992, Wilson installed a Scandinavian chalet but largely obliterated it with a precise replica of the gallery interior, inserted at such an angle as to give the impression from the entrance that Wilson had warped the perspective of the room itself (fig.37). Other works such as the mutilated and re-formed caravan entitled *Face Lift* 1991 (fig.39), and the series of three-dimensional drawings of cheap hotel rooms like *Room 6: Channel View Hotel* 1996 (fig.40), executed in black box-section steel, introduced mutated, abstracted versions with a quizzical mock domesticity that upset the neutral conventions of the gallery.

The combination of cutting, reorganising, inser-tion and hybridisation were now established as Wilson's primary tools. In the major works of the mid-1990s he increased the scale and substance of his interventions, piercing the architectural fabric of the galleries in which they were situated to produce works that emphasised the sly spatial wit that came to the fore in his work during this period.

I'd always liked the way the French artist Arman worked with objects. He would pick up things in his urban environment or things we all know about and use them in this matter-of-fact way. The things in his work would be almost untransformed in many ways, very direct, but at the same time could be very deadpan, very

funny. In one piece he simply layered cars and concrete to make this sixty-five foot high tower that looks like a cliff-face full of the fossils of the machine age. He just called it Long Term Parking. *(fig.38)*

Watertable, made in 1994 to inaugurate the second exhibition space at Matt's Gallery's new location, was a similarly deadpan physical play on words (figs.28, 43). Again the work evolved contingently. Wishing to announce the new gallery as a space of potential, Wilson decided he would leave it seemingly empty, digging through the floor to place an object beneath the threshold of the room. During an exploratory dig made by a structural engineer, it was discovered that London's water table was only three metres below the building. As with the dominant sound of the traffic in *One Piece at a Time*, Wilson took this condition of the site as the defining factor guiding the evolution of the piece. In conversation with Jeremy Till, he described the way in which the work came about:

When I found the water table in Watertable, *I knew I had to link it with something: so a relationship established itself between one kind of table that we know and another kind of table. It focused eventually on the perfection of the billiard table through a whole series of coincidences, like 'sinking the red' – the connotations of water – so suddenly there was a kind of relationship between two very differ-ent things, London's liquid and this other thing, which is about a game, a level, language, the position of the body and so on.*[2]

A twenty-eight-inch concrete drainpipe, easily large enough for an inquisitive viewer to fall into, was sunk through the table like a huge seventh pocket to fuse it with the natural water table at its base.

The idea of excavating beneath the ground of the gallery was used again in *Jamming Gears* 1996 for the Serpentine Gallery in London (figs.41, 42). In both works there are subtle echoes of *Exposing the*

ROOM 6: CHANNEL VIEW HOTEL
1997 [40]
Dexion speed-frame, wheels,
postcard, photographs encased in
clear acrylic
290 x 390 x 580 (114 x 153 1/2 x 228 1/2)
Towner Art Gallery, Eastbourne

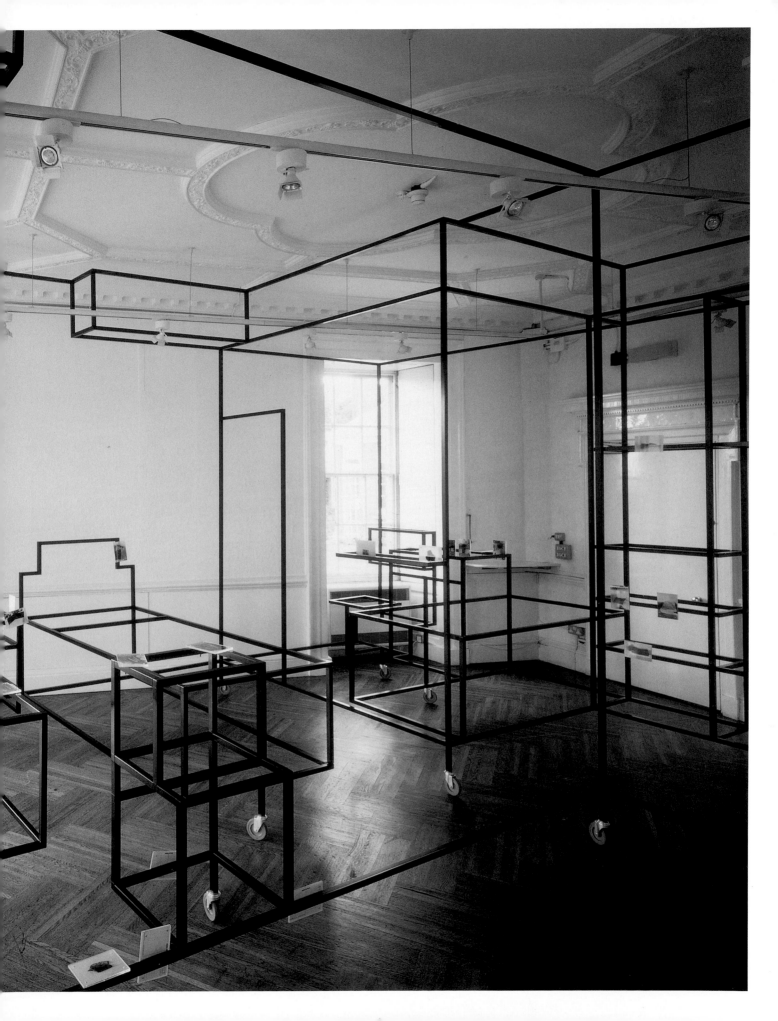

JAMMING GEARS 1996 [41]
Three site units, one forklift truck,
excavated floor, cored gallery interior
and gallery window
Dimensions variable
Serpentine Gallery, London

JAMMING GEARS 1996 [42]
Three site units, one forklift truck,
excavated floor, cored gallery interior
and gallery window
Dimensions variable
Serpentine Gallery, London

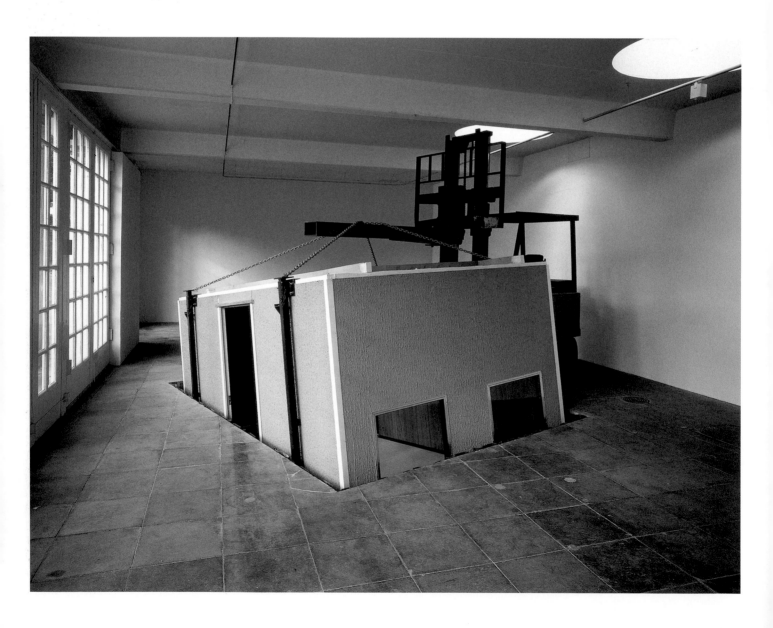

WATERTABLE 1994 [43]
Full-size billiard table, concrete pipe,
ground water and electrics
370 X 210 X 400
(145 ½ X 82 ½ X 157 ½)
Matt's Gallery, London

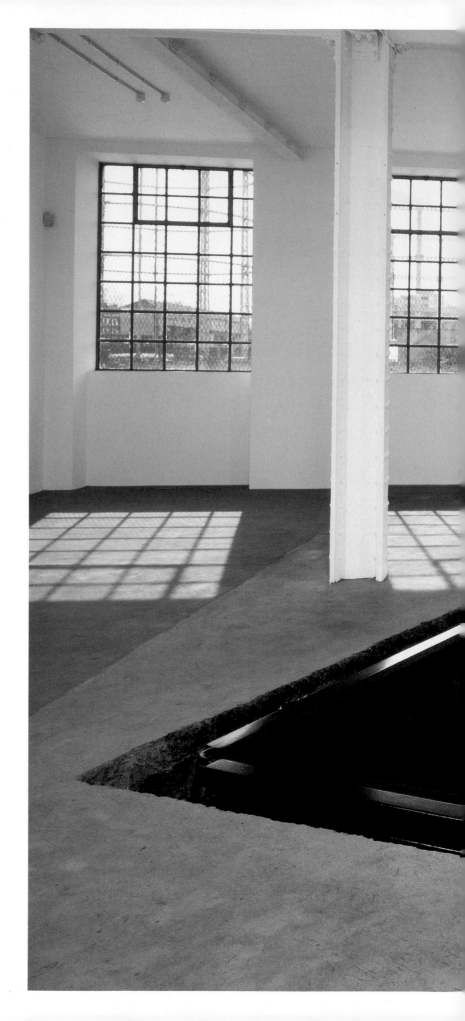

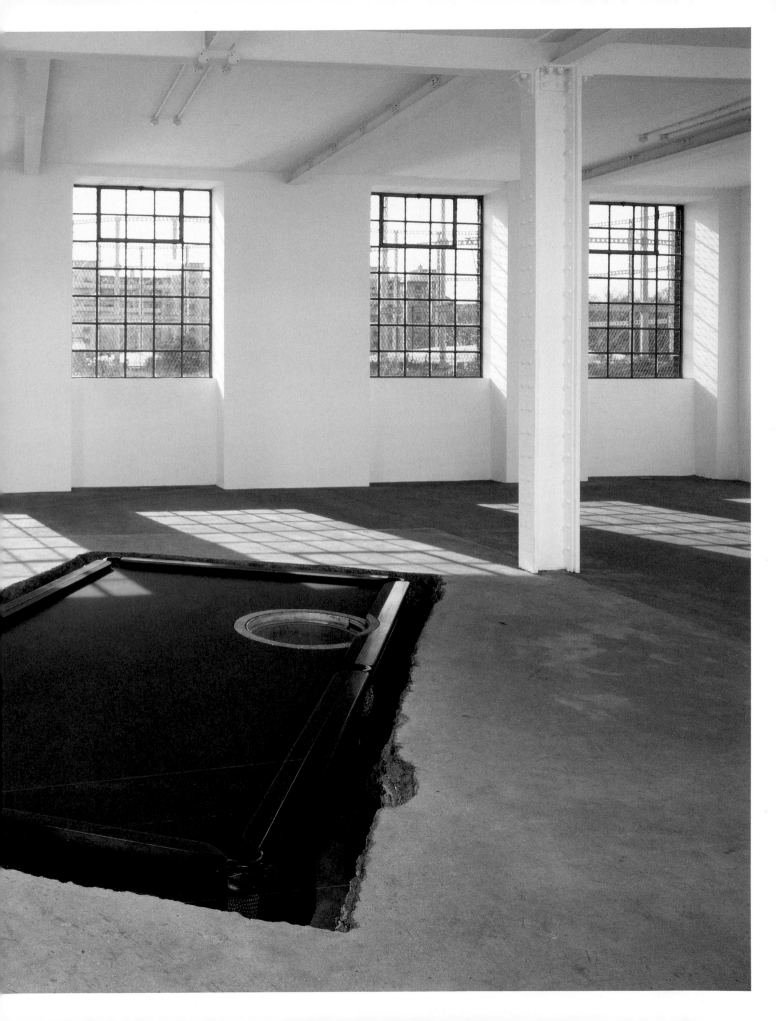

Chris Burden
EXPOSING THE FOUNDATION
OF THE MUSEUM 1988 [44]
(624 X 192 X 108)
Installation at the Los Angeles
Museum of Contemporary Art,
1986–8

Foundation of the Museum made by Chris Burden in 1985, where the artist removed a 52 x 16 foot section of concrete floor from the Museum of Contemporary Art in Los Angeles and excavated the earth beneath to reveal the concrete footings that supported the building (fig.44). But whereas the title of Burden's work framed it as an act of institutional critique, Wilson's title *Jamming Gears* made clear what the critic Michael Archer has labelled the artist's 'reference to the larger world of real work'.[3] Like *Doner* (fig.45) – made in the same year for the inaugural exhibition of the Museu d'Art Contemporani, Barcelona – *Jamming Gears* combined the idea of piercing the museum's apparently solid fabric with the insertion of construction-site motifs. But while in *Doner* this interaction between the result of construction – the museum – and the mechanics of it – a prefabricated building-site office – produced an act of penetration and levitation of surgical austerity, *Jamming Gears* rearranged the Serpentine Gallery like a jigsaw puzzle completed by a Surrealist structural engineer.

Through excavation and dissection, the installation spliced together the temporary building-site architecture of three lurid green site-offices with the boundaries of the gallery, a former tea pavilion. An industrial core-drilling machine was then used to remove cylinders of material from the walls, floors and ceiling of the building, exposing the thinness of the gallery's structural membranes between interior and exterior. Cores removed from one area of the site were inserted randomly into holes left by cores made in other locations, both in the building and in the site-offices, creating an architectural confection flavoured with subversion. Full of holes and literally cutting corners, *Jamming Gears* functioned as a physical manifestation of Wilson's unwillingness to abide by the expected rules of space and structure, the seeds of

which can be traced back to his childhood spent witnessing the everyday magic of construction processes in the builder's yard of his grandfather:

We believe architecture to be incredibly rigid but all the time we see buildings being demolished and others being built over the top of them. We tend to think of concrete and stone and steel as terribly permanent material, but they are all temporary and adaptable in skilled hands. All I'm doing is tampering with the edge of where we think the certainty is in structures, to show it can be altered. Architecture tends to have a certain permanency imposed upon it, but it's a terribly fluid situation. How permanent is a brick? Or a bit of concrete? Or a bit of glass? They're all just materials; they can be changed. Why not see the architecture around us as slow event rather than something solid? We all have preconceptions about architectural space, about rooms, about buildings – whether they're galleries and museums or not – and if you can do something that unsettles those preconceptions you can generate a whole new way of understanding your place in the world.

[1] Jeremy Till, 'Richard Wilson Interviewed by Jeremy Till', *Artifice*, no.2, 1995, p.23.
[2] Ibid., p.27.
[3] Michael Archer, 'Richard Wilson', in Michael Archer, Simon Morrissey and Harry Stocks, *Richard Wilson*, Merrell Publishers, London 2001, p.15.

DONER 1996 [45]
Site cabin, hole in museum wall
and window, two steel I-beams
Dimensions variable
Installation at Museu d'Art
Contemporani, Barcelona

Wilson expressed his view that architecture was a mutable, moldable framework some-what more directly when working on a major new installation to accompany the exhibi-tion of *20:50* at the Museum of Contemporary Art, Los Angeles, as part of the *LA:UK* festival in 1994.

Increasingly frustrated by the dialogue he was having with the museum about his ideas, he made a frantic drawing during a particularly heated transatlantic phone-call in the small hours of the morning. It is annotated as follows: 'LA is so far away I have to conceive of the piece at a desk ... fuck that ... anything goes ... allow for the work ... archi-tecture ain't so precious ... cut it to install the work ... cut the room if necessary!'

Deep End marked a particular evolution in the physical scale at which Wilson was now operating. Whereas *Jamming Gears* had demonstrated his willingness to utilise an entire building as his canvas, *Deep End* heralded his conception of the object on an archi-tectural scale. Exhibited in MoCA's vast, subterranean gallery, the work took the form of a gigantic inverted fibreglass swimming pool on the gallery's ceiling, its Bahamas blue interior connected by what looked like a giant plug-hole to a sixty-foot steel pipe that protruded out of the skylight at street level. Pierced with circular holes, the pool looked like the billowing skirts of some monster jellyfish bearing down on the viewer, but the pipe allowed it to function like a huge ear, funneling down the fumes and sounds from the busy street above.

Discussing the work after its completion with MoCA's chief curator Paul Schimmel, Wilson described the evolution of this cartoonish monstrosity:

The idea for the pool came about while flying into LAX, looking down, seeing all these 1960s modernist shapes of sky blue, and recognising that there were these peculiar lifestyles being lived out in the hills of Los Angeles ... With the pool, I was using an architectural element that engaged the body in a social, as well as a physical, way ...

I needed to build a sculptural installation that worked with, but wasn't lost in, the space. It was only through working with the idea of the pool that I began to consider the gallery in itself as similar to the swimming pool. Just as a contractor digs a hole out of the ground and places a pool into it, [the architect] Arata Isozaki dug a hole out of downtown Los Angeles and put the museum there. I was making connections at that stage, but they were not vital to the idea. It was just a coincidence ...

I suppose you could see Deep End *as a sister piece to* Watertable. *They share certain common elements. The London piece is a billiard table with a cement pipe almost three feet in diameter running deep down into London's water table, making contact with water that*

is in some way agitated. In Los Angeles, the swimming pool was inverted, and a 23 inch diameter pipe ran almost 60 feet up through the skylight and out into the reality of the city. Both works share the pipe as an umbilical cord connecting them to their site, and in that way they break the respective formal barriers of the gallery's ground or roof. They also reflect a certain phobia about the notion of falling down or being sucked up through pipes. Finally, in both pieces I wanted to connect the work to its environment in order to make it less of an object. When you look through the pipe in Deep End, *you see the blue sky of Los Angeles – the reality of the world as opposed to the artifice of the Bahamas blue, the paradise blue, of the swimming pool. The artificiality of the pool is supposed to represent an ideal lifestyle – paradise. Yet in* Deep End, *reality appears, as it were, up the drainpipe.*[1]

Like *One Piece at a Time, Deep End* was one of the few pieces in which a form of social commentary about the situation that framed the work featured as a major inspiration in the creation of the work. In a recent conversation Wilson expanded on how the idea that the swimming pool might be a metaphor for a lifestyle crept up on him. The conspicuous consumption represented by mansions and private swimming pools had impressed itself strongly on him, as had the fact that *Deep End's* companion piece at MoCA, 20:50, was made from the product that made California rich. In its new context the work also gained the potential of acting as a social commentary:

I found myself thinking California – its wealth is based around oil and its leisure time is based around the pool. I realised I was formally presenting two tanks: my tank of oil, and a swimming pool. But those tanks also sort of represented wealth and leisure – the backbone of the Californian dream. I wanted to make a comment about the Californian lifestyle. Los Angeles to me is a city of artifice – everything is so totally artificial. 20:50 is all about the creation of an artificial space, and the way in which the LA swimming pools were painted to make them seem like miniature tropical lagoons seemed to complement this. So you had a sea of money in one room and the leisure paradise that it could buy you in the other. But the oil 20:50 is made out of is industrial waste, and the Californian dream of success isn't a reality for everyone – if you go swimming in the Santa Monica Bay, you need an injection when you come out! So the inverted pool with the rather grotesque, ugly, exterior surface of its shell exposed and these holes cut in it became a pun. It became an idea that 'couldn't hold water' and instead let the polluted air of Los Angeles come down into the gallery.

[1] Paul Schimmel, 'Interview with Richard Wilson', *Deep End,* exh. cat., The British Council / The Museum of Contemporary Art, Los Angeles, pp.13–15.

DEEP END 1994 [46, 48]
Fibreglass swimming pool shell with handrail
and ladders, aluminium pipe
1890 X 430 X 1010 (744 X 169 X 397)
Museum of Contemporary Art, Los Angeles

AERIAL PHOTOGRAPH OF SUBURB
OF LOS ANGELES [47, below right]

BRONZE COLUMN 1992–3 [49]
Proposal for the Henry Moore
Sculpture Studio, Dean Clough
Gallery, Halifax
Cast bronze column
Approximate height 270 (106)

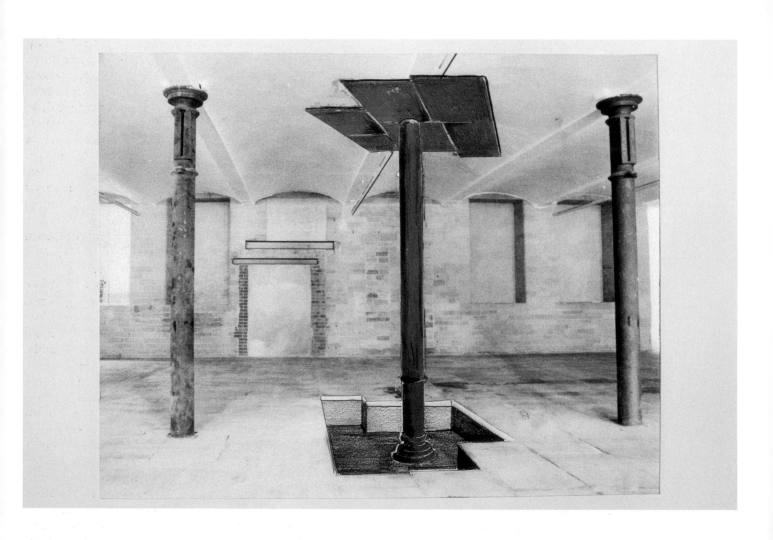

BRONZE POLE OF THE NORTH 1995
[50]
Proposal for Tate Liverpool
Dimensions unknown

MAKE IT LARGE

The way in which Wilson felt compelled to tackle the scale of Arata Isozaki's spaces at MoCA was indicative of a continually expanding ambition for his practice: 'I think it's inevitable really – if you work with architecture as your material and you feel that the work you make should relate to that architecture, eventually you think, 'Why just work with a window or a column? Why not work with the whole building?' And you start making sculpture on an architectural scale.'

Although *Deep End* may have been the first work that could be termed 'architectural' in the sense of its scale, Wilson had been working to the physical parameters of the space since *20:50* and *One Piece at a Time*. Perhaps more important in the development of what could be loosely termed his architectural works, however, is the legacy of *She came in through the bathroom window*. In opening up the possibility of using the fabric of the building itself to manufacture the work, *She came in ...* focused Wilson more explicitly on the nature of the architectural component, and in turn on the basic but fundamental assumptions that these components embody. The strength of *She came in ...* lay in the fact that he had chosen to displace the window from the gallery perimeter into the centre of the room. He could equally have chosen to displace a wall, but this would not have transformed the framing device into an object, nor would it have given mass to the mass-less frame; it would simply have created a different shaped room.

This awareness of the viewer's perception of architecture was developed in Wilson's unrealised work *Bronze Column* 1992–3 (fig.49). Proposed for the Henry Moore Sculpture Studio in Halifax, West Yorkshire, the idea related to the row of iron columns that ran down the centre of the studio's gallery space. He planned to remove one column and replace it with an inverted version cast in bronze. The York flag-stones around its base and the supporting hard-core beneath it would also be cast to form the new column's top-heavy capital. It would continue to function as a structural support because it would be internally reinforced by a steel armature, but would appear simply to be wedged between the ceiling and the hole in the floor left by the original column. Through the manipulation of a single element assumed to be integral to the building's structural solidity, the impression would have been that the intervention had destablised the building.

Bronze Pole of the North, Wilson's 1995 proposal for Tate Liverpool, also unrealised (fig.50), is *Bronze Column's* more challenging sibling. Again, Wilson played with the idea of unifying the sculpture and the environment in which it was viewed, and again that relationship was focused on structural destabilisation. But unlike *Bronze Column*, *Bronze Pole of the North* illustrated a strange structural fluidity belied by the solidity of Tate Liverpool's construction.

The work took the form of a single, thin bronze pole, whose tip would be located in the middle of the floor of the upper gallery, and which would descend down through the building, visible at every level. Formally, *Bronze Pole of the North* is similar to a work made by the American artist Walter de Maria in 1977 for Documenta, an international survey of contemporary art held in Kassel, Germany, every five years. *Vertical Earth Kilometre* took the form of a kilometre-long metal rod buried vertically in a shaft that penetrated six geological layers of material in the middle of a public square (fig.51). Only its tip, two inches in diameter and surrounded by a sandstone slab, was visible. Although intensely material in the sense that de Maria actually did sink the rod a kilometre into the earth, the work's impact is conceptual in the sense

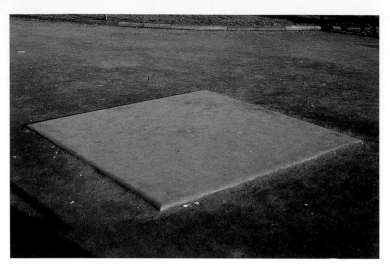

Walter De Maria
VERTICAL EARTH KILOMETRE
1977 [51]
Solid brass rod, earth, red sand-
stone plate
1 kilometre deep
Documenta VI, Kassel

that the viewer has to imagine its descent through geological time and space, rather than witness it. In contrast to this, the interaction between Wilson's vertical rod and its surroundings was precisely the point. Like de Maria's work, Wilson's rod entered a bore-hole beneath the ground, but rather than being determined by any abstract measurement, the limit of its descent was dictated by the point at which it reached the bedrock of the river Mersey, where it was to be firmly anchored. Decidedly site-specific, the work depended on the fact that Tate Liverpool is situated on Albert Dock, which as Wilson explains, has an unusual structural characteristic:

I was one of five artists invited to go and view a site on the edge of the Mersey that Merseyside Development Corporation wanted to tart up with public art. The site was a bus station where Liverpool buses terminated – a completely miserable location, totally uninspiring as a place to make art.[1] At lunch I got talking to one of the older councillors and he asked me if I knew that the whole of Albert Dock, where Tate Liverpool is situated, actually moves. I asked him what he meant and he told me that because the dock was built on wooden pilings, rather like Venice, every high tide the timber would swell with the increased pressure of the water. That absolutely intrigued me, and it was the worst thing I could have heard with regard to the reason I was supposed to be in Liverpool because it completely knocked on the head any idea of thinking about public art works for depressing bus stations! All I could think of was the idea that the Tate actually moved.

So I went back home and threw myself into a series of drawings. The idea was to core right down through the Tate galleries, through the basement and down into Liverpool bedrock. Then you'd insert a solid brass rod like de Maria's Vertical Earth Kilometre, *skewering the building into the bedrock. So the pole would be pinned into the*

planet but not into the building. On the top floor at high tide there'd be a three-inch bronze circle absolutely flush with the floorboards, rather like one of those little brass plates that cover electricity sockets. And you'd go in and think 'Well, where's the show?' But as the tide went out the piles would contract and the building would drop until at low tide you'd have about an inch and a half of pole sticking out of the floor. You'd have this minimal work that made this extraordinary phenomenon – the building moving – visually and physically graspable. You'd have this lovely inversion of how we expect things to behave – all this stone going up and down and this one little pinprick staying static!

Perhaps unsurprisingly, Wilson could not persuade Tate Liverpool to realise such an ambitious temporary work when its remit was not to commission but to show the Tate's collection on a rotating basis. But the work highlights an important dichotomy that Wilson and other artists working with architecture were to encounter during the 1990s as the perception of contemporary art as a 'cultural economy' began to develop: inspiration and the facility to realise it seldom came together. The convergence of shrinking institutional budgets and the introduction of new mantras into the public sector requiring consumer-led services and greater accountability created a climate where museums and galleries became either unable to afford, or simply unwilling to commission, ambitious works that were expensive or would necessitate long periods of closure or interruption to their programmes. Meanwhile, the idea of public art – usually situated in the urban realm – became increasingly popular as a means to aid programmes of economic and social regeneration, being presented by its advocates as a generator of social focus and identity. Artists such as Wilson, who focused on ideas of space and structure in their work,

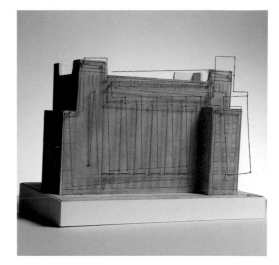

THE JOINT'S JUMPING 1996–9 [52]
Proposal for Baltic Centre for
Contemporary Art, Gateshead
Neon tubing, north-facing wall of
the former Baltic Flour Mill
Dimensions variable

THE JOINT'S JUMPING 1996–9 [53]
Proposal for Baltic Centre for
Contemporary Art, Gateshead
Neon tubing, north-facing wall of the
former Baltic Flour Mill
Dimensions variable

or who addressed the physical or social contexts of architecture and place, were obvious candidates for public art commissions. However, although the commissioners often had access to the kind of budgets that ambitious artists desired, the art they funded often had to be justified in terms other than its ambition as art and was frequently made subservient to both architecture and urban planning. Wilson was far from alone amongst artists approached by public art commissioners in finding that his proposals were rarely realised due to their ambitious scale and tendency towards intervention into the architectural fabric. This was predominantly a conservative sector, branded by some critics as more likely to produce 'turds on the plaza' or 'lipstick on the face of the gorilla' than memorable art.

Wilson had to wait until 1999 to realise a public work on an architectural scale in Britain. Ironically, it was one of his most ambitious ideas for an architectural intervention to date. In the meantime he continued to explore ideas involving the unexpected movement of a building established in *Bronze Pole of the North. The Joint's Jumping*, for example, his unrealised proposal of 1996 for Baltic Centre for Contemporary Art, Gateshead, was an elaboration of a basic animation technique onto an architectural scale (figs.52, 53). The building's form was to be outlined in orange neon light at its actual position and at a displaced angle. At night the neon outlines would fluctuate, making the building appear to shake up and down on its foundations.

Like *The Joint's Jumping*, the idea for *Over Easy* could be applied to many architectural facades and could be seen as a form of architectural animation (figs.54, 55). But unlike *The Joint's Jumping*, *Over Easy* consisted of little more than the fabric of the building itself. It was made for the newly built performing arts

centre The Arc in Stockton-upon-Tees, a three-storey building characterised by a sweeping glass and concrete facade and located on a derelict corner site at the intersection of a number of major roads. As the centre was being designed concurrently with Wilson's proposal, he developed the idea in dialogue with the architect. He saw the work as a pure manipulation of architectural fabric that animated the building in a radical way whilst appearing almost invisible, a literal statement of his belief that architecture should be seen as a mutable, moveable entity rather than a static form.

The work consists of an eight-metre diameter purpose-built bearing – two steel rings that rotate concentrically on ball-bearings – that was integrated into the fabric of the building during construction. When static, the building simply appears to have a circular detail intersecting the glazed area as well as the concrete part of its external wall. But when it slowly begins to move, this section oscillates through 300 degrees, swinging alternately clockwise and anticlockwise between ten and two o'clock. The deceptive ease with which this feat unfolds belies the complexity of the engineering that has gone into its achievement. This was vital to the way in which Wilson intended the work to effect the viewer:

I wanted the person walking by in the street to be hit with the actuality of eight metres of facade moving before they had time to think how it was done. I wanted to stop them first with that sense of spectacle then let them try and digest it, to start looking at the details and unravel the story of what the piece is about.

Over Easy transformed The Arc from a conventional building into one in which the architecture physically displaces itself, resulting in the only building that travels 400 miles a year whilst staying in exactly the same place. It represents Wilson's most

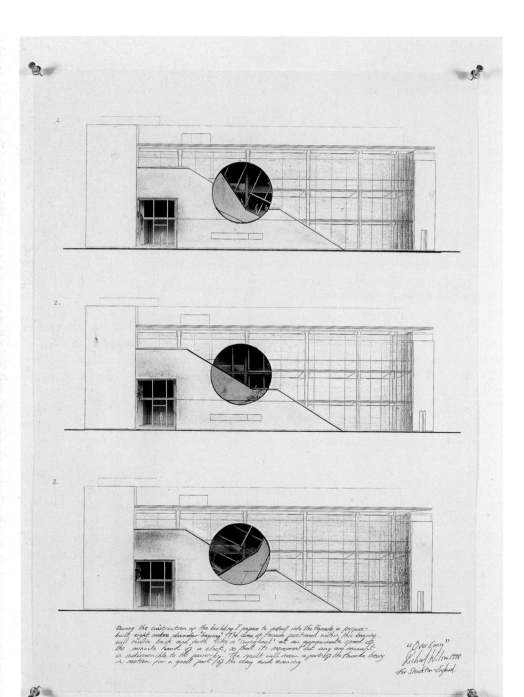

During the construction of the building I propose to install into the facade a purpose-built eight metre diameter "bearing". The area of facade positioned within this bearing will revolve back and forth like a "swingboat" at an approximate speed of the minute hand of a clock, so that its movement at any one moment is indiscernible to the passer-by. The result will mean a part of the facade being in motion for a good part of the day and evening.

"Over Easy"
Richard Wilson 1998
for Stockton-England.

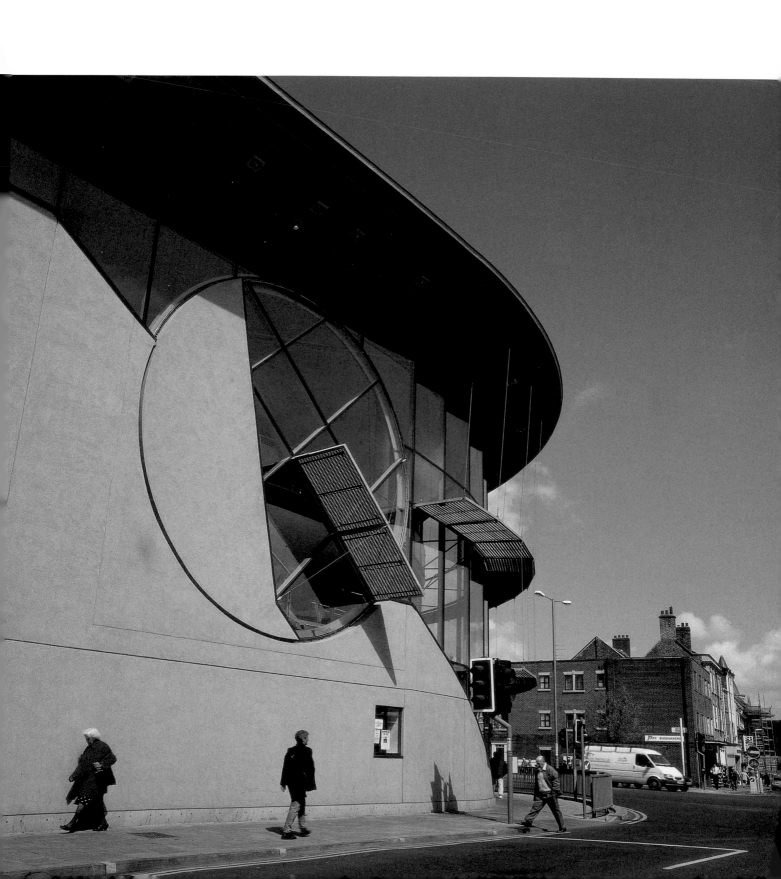

OVER EASY 1999 [55]
Steel, glass, electric motors, render,
PVC seals
Diameter 800 (315)
The Arc Trust, Stockton-on-Tees

ENTRANCE TO THE UTILITY TUNNEL
1994 [56]
Aluminium and stainless steel
620 x 150 x 540 (244 x 59 x 216)
Faret Tachikawa Urban Renewal
Project, Tokyo

ambitious extension to date of the strategies estab-
lished in *She came in through the bathroom window*.
As with that earlier work, *Over Easy* re-edits the
architectural material that is expected to house art,
allowing it to become the point of focus itself. It func-
tions as a flag for what is contained within, the build-
ing's performance announcing its nature as a
performing arts centre.

The only publicly sited work that Wilson had
realised before *Over Easy* was *Entrance to the Utility
Tunnel*, made in Tachikawa, a suburb of Tokyo, in
1994 (fig.56). Built to conceal the maintenance stair-
well that gives the work its title, the sculpture took
the form of a cast aluminium replica of a domestic
staircase, but one that went nowhere, and was
enlarged to a scale that dwarfs the viewer. This Alice-
in-Wonderland play on the gigantic and the miniature
was inspired by the sense of displacement of scale and
disorientation that were the artist's dominant impres-
sion while in Tokyo. He was to return to this reloca-
tion of familiar architectural structures the year
following the realisation of *Over Easy,* when he was
again invited to create a permanent work in Japan.

Wilson's sense of being culturally adrift in Japan
was magnified in 2000 when he was invited to create
a work for an unused corner of the grounds of the
Junior school in Nakasato Village, located in the stun-
ning landscape of the rural province of Niigata
Prefecture. Describing himself as an 'urban person at
heart', he confessed to 'not really being able to relate
to the rural environment'. Since he had no architec-
tural canvas with which to work, he decided to
import one, and as with *Entrance to the Utility Tunnel*,
it was a Western domestic structure, in this case, his
own home.

Set North for Japan (74° 33′ 2″) was a full-scale
reconstruction of Wilson's London terraced house,

reduced to a steel frame but displaying his signature
attention to spatial detail (figs.57–9). The work was
not simply infiltrated into Nakasato like some English
cuckoo in a Japanese nest, but placed there in the most
blatant fashion. Upside down and rising up at a
displaced angle it retained its precise relationship to
its original site, its exact perpendicular and horizontal
orientation to True North. If *Entrance to the Utility
Tunnel* was straight out of Lewis Carroll's Alice
adventures, then *Set North for Japan* (74° 33′ 2″) owed
its atmosphere to another classic tale of a young girl
displaced to a magical other-world. It was as if the
frame of the house had literally been torn free of its
foundations in England and come crashing to earth in
Japan, as Dorothy's house was uprooted from Kansas
by the tornado in *The Wizard of Oz*.

[1] The bus station was being removed from Pier Head
and Merseyside Development Corporation, a govern-
ment 'task-force' that invited artists to propose art as a
part of a new landscaping scheme by Allies and
Morrison (who later landscaped Tate Britain).

SET NORTH FOR JAPAN (72° 33′ 2″)
2000 [57]
Painted steel, concrete base
880 x 460 x 140 (346 x 181 x 55)
Echigo-Tsumari Art Triennial 2000,
Nagasato, Niigata Prefecture

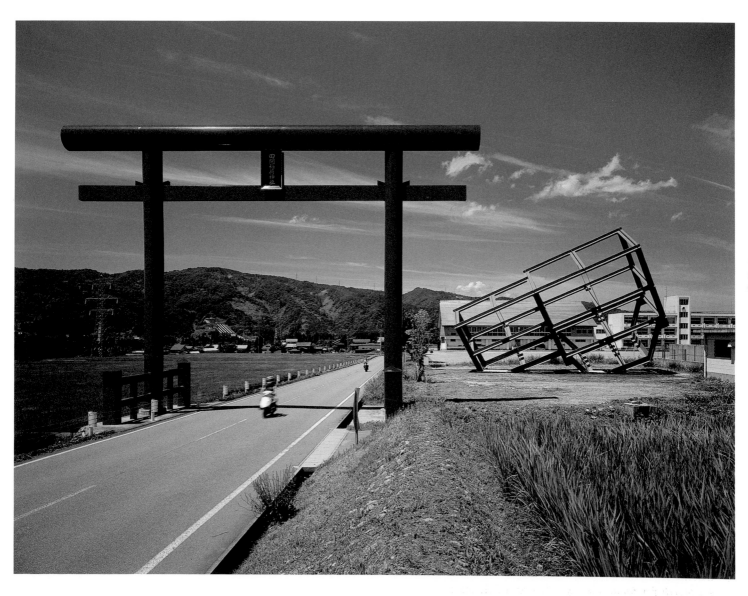

SET NORTH FOR JAPAN (72° 33′ 2″)
2000 [58]
Painted steel, concrete base
880 x 460 x 140 (346 x 181 x 55)
Echigo-Tsumari Art Triennial 2000,
Nagasato, Niigata Prefecture

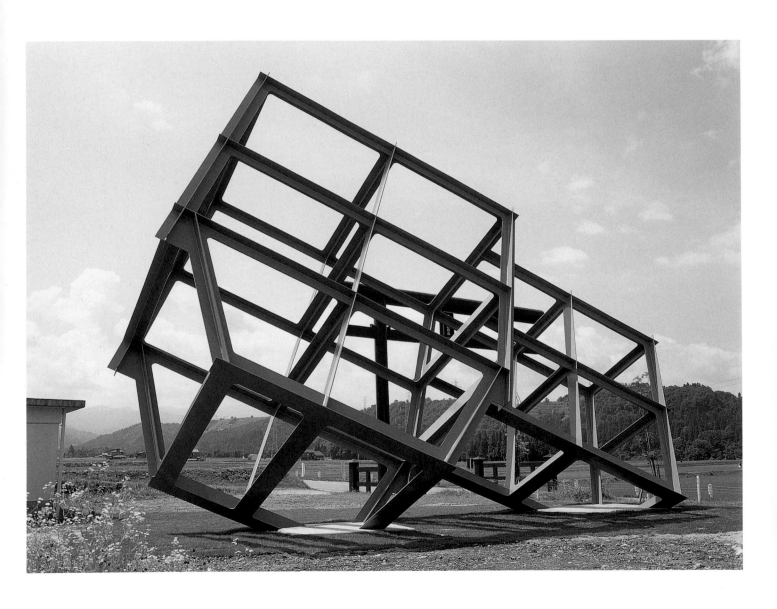

SET NORTH FOR JAPAN (72° 33′ 2″)
2000 [59]
Painted steel, concrete base
880 x 460 x 140 (346 x 181 x 55)
Echigo-Tsumari Art Triennial 2000,
Nagasato, Niigata Prefecture

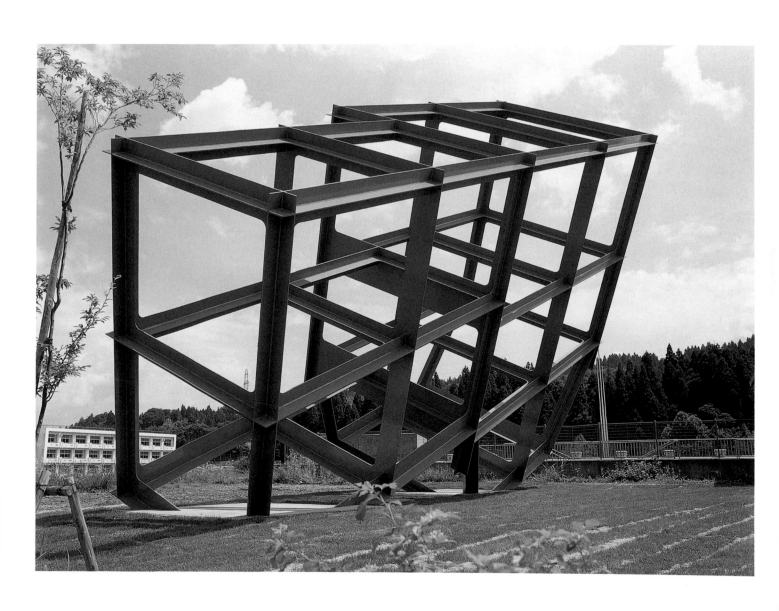

SLICE OF REALITY 2000

SLICE OF REALITY 2000 [60]
Section of 700-ton sand dredger
on six piles in the river Thames,
Greenwich, London
2100 x 975 x 790 (826 x 383 x 311)
New Millenium Experience
Company (MNEC), London

Although *Set North for Japan* (74° 33′ 2″) took its form from a building, the work is to all intents and purposes a sculptural object, albeit one rendered on a monumental scale. The same year, *Slice of Reality* was unveiled as one of the major publicly sited works commissioned for the Millennium Dome at Greenwich Peninsula, London. These two works represent Wilson's tendency to take his own architecture to a given site, stemming from the gallery installations of the mid-1990s featuring chalets and site-cabins.

Invited to create a work for the Dome site, Wilson immediately found himself more excited about locating his work in the mud at the edge of the river Thames that skirted the site than in the areas formally designated as framing the Dome. This attraction to the Thames was nothing new for the artist, who had grown up in London and lived his whole adult life in areas of east or south London bordering the river. Talking to Lynne Cooke in his first major interview when making *Heatwave* in 1986, he described how he found metaphorical inspiration for his work in the constantly shifting nature of the river, the rapid changes of the waterfront environment and the traditional industries associated with it.[1] This fascination deepened throughout his adult life into an in-depth knowledge of the history of the Thames and its shipping. The clash between the almost fatal decline of the traditional industries spawned by the Thames and what he perceived to be the superficially optimistic nature of the government-sponsored Millennium celebrations was slowly but steadily to influence his engagement with the Dome site:

Whenever I start a piece of work I begin the process by trying to understand the particular nature of the site and the reason for making the work. For me that's the springboard that moves me towards an idea. So with Slice of Reality *I was thinking, 'What's this place about?', and that couldn't help but include the Millennium Celebration itself, because the Dome was completely altering the site. What had been post-industrial wasteland was being turned into this strange theme park. So I found myself thinking 'What is this millennium celebration all about? It's all about this supposedly defining moment, so how can I put something in the river to parallel that?'*

These questions were mixing with formal ideas about the site: the fact that that part of the Greenwich Peninsula is divided by the Greenwich Meridian, so the idea of slicing space up began to play an important role. And then there was the fact that the whole of Greenwich is awash with maritime history. I suddenly realised that what I needed was to take an architectural form from the river, a piece of maritime architecture – a ship – and slice it to create a physical moment rather than a whole.

So the way I was thinking about the piece at first was quite formal, and this is normally

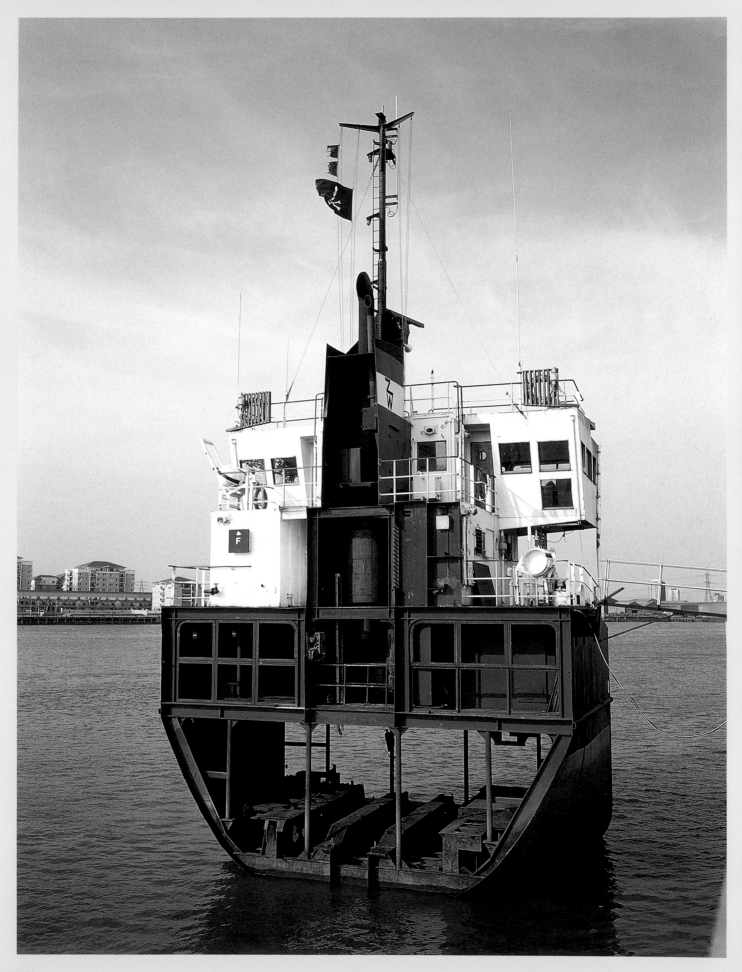

SLICE OF REALITY 2000 [61]
Section of 700-ton sand dredger
on six piles in the river Thames,
Greenwich, London
2100 x 975 x 790 (826 x 383 x 311)
New Millenium Experience
Company (MNEC), London

the case. The concentration when I went to art school was on the formal understanding of sculpture and that way of thinking has inevitably sunk into my way of seeing things. I loved the formal simplicity of the idea of slicing up the ship. It was so easy to describe the process through which the work would be made because it's no different from slicing a loaf of bread, but I knew the actual sculpture would be quite an extraordinary displacement because of the sectioning of the structure and the parcels of space that would be revealed within it.

There was also this idea from the beginning that the Millennium celebrations were all about making something new and in doing so, celebrating the future. But there seemed to be no real direction at the Dome; a lot of money was being spent with no real idea of what we were supposed to be celebrating. I think I reacted against that, and I liked the idea that instead of falling into line you could draw from the past, for example taking a ship that had had its life and was now defunct, and by tweaking it making a point about all this unthinking celebration of newness. I suppose it was a bit of a case of biting the hand that feeds.

So I went ahead and bought a beautiful old dredger called the Arco Trent. Because of the decline of the shipping industry in Britain I couldn't get the piece made in the South and had to take the ship up North to find an outfit that could carry out the work I needed. River Tees Engineering and Welding reduced the ship in length by 85 per cent, leaving only a vertical portion housing her habitable sections like the bridge and accommodation deck.

It was only whilst making the piece, through working with the ship and with an industry associated with it, that I began to realise how much the specific nature of the material I was using, and what I was doing to it, had meanings that knocked all of the formal aspects that I've spoken about into touch. Bob Gibson, one of the Directors of River Tees Engineering and Welding, said to me that for him the work was a metaphor for the state of merchant shipping in Britain today – 'Sunk, shrunk and the heart torn from it.' I realised that Slice of Reality couldn't help but make a statement that said 'I was a ship and I am no more', and that putting it back in the Thames emphasised the lack of merchant ships on the river. We used to send a thousand ships a week out of the Thames – the traffic was constant. That industry just doesn't exist anymore. Except for the pleasure cruisers and the police, the Thames is virtually empty now. So I put the slice in the mud at Blackwall Point and she'll just sit there and slowly rust as something that was once proud and is now broken.

[1] Lynne Cooke, 'Richard Wilson Interview by Lynne Cooke', in *Heatwave*, exh. cat., Ikon Gallery, Birmingham 1986, p.10.

SLICE OF REALITY 2000 [62]
Section of 700-ton sand dredger
on six piles in the river Thames,
Greenwich, London
2100 x 975 x 790 (826 x 383 x 311)
New Millenium Experience
Company (MNEC), London

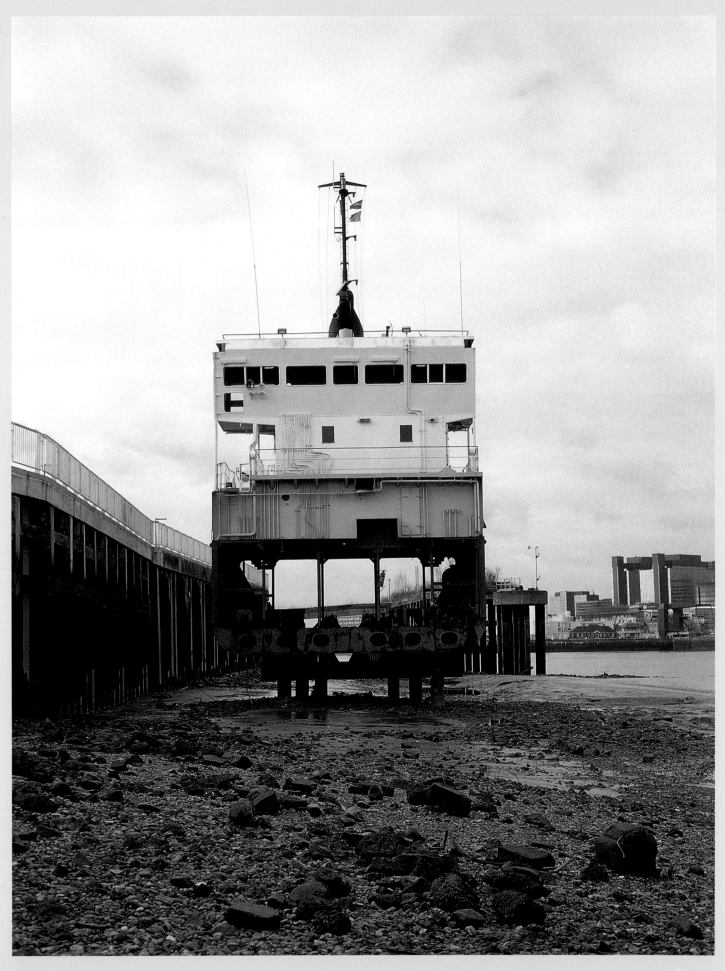

TURBINE HALL SWIMMING POOL
2000 [63]
View of swimming pool at
Southwark Park, London

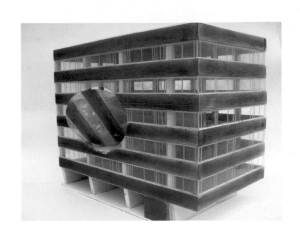

TURNING THE PLACE OVER 2000
[64]
Turning section of building
facade, rollers, steel

Maquette for Birmingham, 2005

5

REDUNDANCY

Slice of Reality, a forlorn object, stripped of its function and purpose, stood in sharp contrast to the Millennium Dome and its peculiar funfair-meets-supermarket attempt at celebration. Although it was described in the guide to the Dome in the feel-good language of public relations as a 'celebration' of merchant shipping on the Thames, the tenor of the work was far from simplistically positive. As Wilson intended, almost as soon as the work was installed it started to show signs of deterioration. Rust bled from under the paintwork, streaking the truncated vessel with corrosion. Algae colonised the bilge where the river entered inside what was once the engine room, and the tattered flags that flew from the mast announced: 'I am aground but require no assistance.'

With the financial scandal that tarnished the Dome's short official life, *Slice of Reality*'s ability to lament the loss of skills and communities from the Thames and simultaneously make a critical statement about the superficial nature of the official Millennium celebrations acquired an almost prescient quality. At the end of the celebrations the Dome entered a kind of limbo, locked up and patrolled by security guards but used for nothing. Wilson's negotiations with the Port of London Authority to leave *Slice of Reality* in situ permanently means that the sculpture still sits in the mud a few metres off from the river wall at Blackwall Point, but now does so against the backdrop of a Dome site as tarnished, deteriorating and given over to the encroachment of weed as the sculpture itself.

With *Slice of Reality*, Wilson confirmed the tendency that had permeated his career to recycle materials from the real world and in doing so to reassign the way they function in the world. The fact that this material and the processes he uses to reconfigure it are often derived from the spheres of industry and construction can prompt reflection on these materials

as possessing social meanings as well as physical properties. But Wilson's use of an object with such an explicit set of associations as the derelict Arco Trent, signalled a more direct awareness of the social context that can surround his work.

In recent years I've become much more aware of the social aspects of sites and their histories, as well as their physical characteristics, and how this might influence the work I make. I've also become more aware that there are themes that recur all the time in my work, like the idea of things becoming redundant and how you can reanimate them, give them new life and meaning. But I think the idea of the work making some form of comment is something I've only fully got to grips with recently. It's not that its necessarily completely new in the work; I think it was there to some degree in works like Hopperhead, *and definitely in* One Piece at a Time *and* Deep End, *but it emerged in those pieces in the shadow of formal concerns. Since beginning* Slice of Reality *I find myself considering those things as part of the context that my work might respond to. Whether it comes into play or not is down to the nature of the site and what that gets me thinking about.*

It is not surprising that this expanded notion of context has had most influence on the formulation of recent works that have been made outside of the gallery. Beyond the deliberate neutrality of the gallery, physical context is likely to be only one part of a site's inherent conditions, since its identity is determined as much by its social and historical context as by its physical parameters. But it is of particular note that Wilson's increasing absorption in the thematic continuity within his work has generated ideas for works that respond to particular genres of sites rather than to the specific identity of a particular site. The most substantial case in point is *Turning The Place Over* (figs.64–7). Initially formulated for the Year of Architecture, held in Glasgow in 1999, and developed

over subsequent years with structural engineers, *Turning the Place Over* is similar to *The Joint's Jumping* and *Over Easy* in that technically it could be applied to any suitable building, not just the building for which it was conceived. In this way it continues the idea of the transferable installation established with *20:50*. Unlike all of these works, however, *Turning the Place Over* was not conceived with the specificity of a site in mind, but rather for a type of building – one that was both derelict and substantial in scale.

The work of Gordon Matta-Clark has frequently been cited by critics as a framework for Wilson's installations, but it is only in *Turning the Place Over* that he has actually embraced the derelict building so familiar as Matta-Clark's site and material. Perhaps more fundamentally, *Turning the Place Over* also features the irreversible structural intervention that characterised seminal works by the earlier artist, such as *Conical Intersect* 1975 or *Day's End* 1975 (fig.68). For the former, starting from a four-metre wide opening in an exterior wall, Matta-Clark cored a cone-shaped void through two Parisian townhouses. The latter consisted of a vast ellipse cut from the corrugated metal end of a massive New York warehouse and a corresponding semi-circle cut from its floor to expose the river beneath.

Wilson's work is not created with the same sense of heroic personal endeavour that infused Matta-Clark's architectural interventions, due to the fact that he created them by hand. In terms of its physical scale and its kinetic nature, however, *Turning the Place Over* is arguably as ambitious in conception as any project realised by Matta-Clark. For this work Wilson proposed cutting a ten-metre diameter ovoid section out of the facade of a disused building. This would then be mounted either in the mouth of a huge pipe or onto a central spindle that would be inserted into the building so that the removed section of facade fitted back flush into the hole, leaving only the ovoid shape denoted by the cut as evidence of alteration. The pipe or spindle would be mounted on a set of powerful motorised rollers, such as those used to rotate the hulls of ships during welding, allowing the section of facade to rotate through 360 degrees. As it became inverted, it would also oscillate deep into the building and far out into the street, only being flush with the building at one point during its rotation.

Although *Turning the Place Over* would physically re-animate the redundant, the particular nature of the transformation leads to an interpretation more complex than, and perhaps contrary to, the suggestion that art can breathe new life into the discarded. In opposition to the slow movement of *Over Easy*, to which *Turning the Place Over* bears a surface similarity, Wilson intends the rotating section of the building to move with enough speed to induce a palpable sense of physical threat in viewers as the slab of architecture moves out of the confines of the building to encroach physically on their space. Whether due to its sheer physical ambition or a menacing presence out of step with the positivist mantras on urban regeneration voiced by developers and councils, at the time of writing *Turning the Place Over* has yet to be realised. It would be difficult to describe the work in the language of urban regeneration, for example, as 'the old given new dynamism', when that dynamism is one that suggests a potential threat to those around it.

That the material Wilson chooses to manipulate has a recognisable pre-existing function has always been fundamental to his work. It is notable, also, that in recent years his interventions into this material have become increasingly restrained. In this way, the works can often appear to be things from the real

TURNING THE PLACE OVER 2000
[65]
Turning section of building facade, rollers, steel

Maquette for Glasgow, 2000

TURNING THE PLACE OVER 2000
[67]
Turning section of building facade, rollers, steel

Maquette for London, 2002

TURNING THE PLACE OVER 2000
[66]
Turning section of building facade, rollers, steel

Maquette for Liverpool, 2004

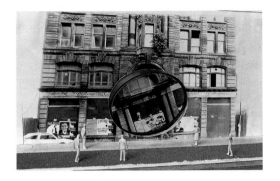

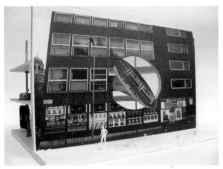

GMS FRIEDEN

"and now here's what happened next. When I bought the stern in 1975 for DM 230,000 I bought this at the shipyard and added it on. Underneath the stern cabins is the machine room. There are two fuel tanks there, port and starboard with the engine laying central. The starboard tank was 5,500 litres capacity and the port 6,000 litres capacity. When all that construction was finished, I went to the station and bought 10,000 litres of fuel... and here's what happened... ■ I started off with my ship from the shipyard to Duisburg on the Rhine and I loaded up with 600 tons of coal for Berlin. And now on the way we were at Minden in Westphalia, the halfway point of the trip. Here the Mittellandkanal crosses the Weser and is called the Weserkreuz. ■ After Minden on the way to Hannover my engine did not want to draw air anymore – the speed kept going down and up and I could not get her up to a regular speed. I couldn't figure out why the motor would run sometimes 350 R.P.M. and sometimes 500 R.P.M. When you start up the engine her slowest speed is 80 R.P.M. and the maximum capacity is 500 R.P.M. full speed. You have of course these pipes that run to the engine through filters directly from the fuel tanks. I stopped and moored the ship and then went down into the machine room and the first thing I did was to figure out what was going on... then I saw that there was air in the filters. But then I realised that I still had 7,000 litres of fuel in the tanks so it couldn't be a lack of fuel. I cleaned up the filters and started off again. And we went along for about an hour and the same thing started happening again, slow – fast. And then I had to moor to some trees as there was no mooring place. I picked out some big trees to moor to because, if the engine suddenly stops, I have no control anymore. So I stayed tied up to the trees for six hours and spent my whole time down in the engine room looking till I found out the idea. Suddenly I realised that in front of the 6,000 litre tank is a flange on the fuel line. So I opened up the flange because I wanted to look in there and see if the fuel was flowing through it, as it ought to be. I put a big bucket under it and at the beginning about five or six litres of fuel came out in one big rush. So I knew something was in the fuel tank but what? So then I replaced the flange. Now, there is a wall between the tank and the motor and the tank wall was two metres high. The tank's outer wall curved to the curve of the ship's stern quarter. I couldn't continue... I had to go into the tank itself. The tank was two metres deep and at the front was a man hole cover made for a man to go through but this cover was oval shaped. This cover was 125 centimetres up from the floor. Now, in order to be able to open this cover, I had to pump some of the fuel from the stopped up tank into the other tank. Now all of that with a handpump. So I pumped it down until there was only 125 centimetres of fuel in the tank and then I had to take off the cover. I remember there were 58 bolts and of course with seals. So I took off the lid but there was fuel up to that level. Now, down on the near right corner as I faced into the tank was where the fuel pipe left the tank. So from outside I tried to reach that outlet with a piece of wire. I fished around there because I had the feeling there may be a piece of rag or handkerchief down there but this didn't work so I now had to take off all my clothes and go into the dark tank. 125 centimetres was roughly up to my chest level and I don't have such a long arm that I could reach all the way to the bottom. Before I went in I covered my whole body in propshaft grease and then I went in. First I felt around the bottom with my foot and I could feel some sort of rag and a few pieces of metal and for a few seconds I had to immerse myself in the dark diesel diving to the fuel outlet. ■ It was September 1975, in comparison to today let's just say I was a young man then. Now I'm in my sixty second year – it was 18 years ago. First using handfuls of grease I closed up my eyes, ears, nose and finally I took a big gulp of air and closed my mouth with grease. And then I plunged into the diesel. I reached down and grabbed the rag. This rag was part of a coat – a big chunk of coat. Now there are three theories how this piece of fabric got into this spot. The first theory was they were once cleaning the tank and left it in there. The second theory was when they were putting the tanks together they had been doing some welding work and somebody had been cooling the welds with this sodden rag. Or the third version was that, being a company ship, one of the sailors who had been doing the work had, after filling the tank, thrown the piece of cloth into the tank because he was unhappy with something and this was his form of a boycott. ■ When I came out of the tank my wife Hildegard gave me an old pair of trousers and a jacket and I wore these to soak up all the grease and diesel. I – as captain – had to ensure everything was in order before I could continue and it wasn't until evening that we headed off to a proper mooring with piers. So we set off, 6 or 8 kilometres to the mooring site, and I wore these clothes for that period. In the meantime, the engine was producing hot water again so that when I moored up I filled up the bath with hot water from the machine room and took a long bath and washed everything off. Diesel itself doesn't smell that bad particularly – I mean the machine room always smells of diesel and I'm used to the smell. It's the taste I remember. I had diesel in my mouth and it took a long time to get rid of the taste. It seemed to always be there and now when I'm working with an engine and I get diesel on my lips that intense taste comes back...

When we began to scrap the ship I stood there and tried to record everything with video and still camera. And as I stood there all eighteen years of my experience with this ship began to pass in front of my eyes, all the most serious and intense moments came back to me including this experience and I stood there and did not want to cry but I was being shaken and the tears just ran down my cheeks. I could not help myself and in the course of eight days I lost seven kilos of weight and by February 11th 1993 the ship was no longer."

– This true account was told to me by
Kapitän Siegfried Schauder of the ship FRIEDEN

Richard Wilson
Berlin 1993

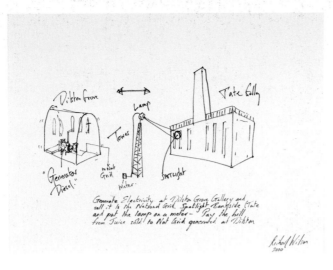

TURBINE HALL SWIMMING POOL
2000 [71]
Ink on paper
Collection of the artist

industrial sector. Wilson had created *Hopperhead* for the Café Gallery in 1985, and in 2000, the gallery invited the artist to make a new work. In the fifteen years that had intervened, a circle of redundancy and regeneration had played itself out around the gallery. Three years after *Hopperhead* had been installed, the swimming pool it had attempted to pump dry had been closed due to vandalism and was never again reopened (fig.63). In 2000, the gallery appeared to be as derelict as the overgrown pool, but was boarded up for the opposite reason: it was undergoing a major renovation and expansion. Since the gallery was inaccessible, Wilson was invited to make a work for the vast and near derelict former Clare College Mission Church, long deconsecrated and abandoned, that stands on the edge of Southwark Park. Wilson was very familiar with these sites, not simply because of his previous exhibition, but because the park was within walking distance of his home of more than twenty years.

The critic Michael Archer has outlined how, as with *Slice of Reality*, the formation of Wilson's work was heavily influenced by the area's redundant uses being brought into sharp contrast by contemporary developments:

A short distance up river from the park, the new Tate Modern gallery was opening in a converted power station. As with the Dome, built on the reclaimed land of Greenwich peninsula, Wilson saw Tate Modern as embodying the transformation of an industrial past into a future in thrall to spectacle, leisure and excessive consumption. Using the swimming pool as the derelict venue for a rejected form of communal relaxation and enjoyment, he instigated his own counter-model of the turbine, one that would offer a stubborn alternative to the fate of the Bankside building.[1]

That counter-model of Tate's Turbine Hall was to be housed in the derelict church, inverting Tate Modern's conversion of the once-derelict cathedral of power generation into art gallery by turning the temporary venue for art into a generating station that presented a metaphor for loss of energy, redundancy and its human cost (fig.71).

[1] Michael Archer, 'Richard Wilson', in Michael Archer, Simon Morrissey and Harry Stocks, *Richard Wilson*, London 2001, p.19.

Because I live close by and know the context of the area so well, going into the old church I found that I wasn't just thinking about what is actually a very particular space physically. The interior of the church was stripped out when Clare College Cambridge gave up on it, so it feels more like a concrete bunker than a place of worship. It feels gutted rather than just neglected. That just underlined for me the fact that the church used to be a community space but was now totally lost. I was also obviously thinking about making Hopperhead *for the Café Gallery back in 1985 and the fact that the pool was now derelict and lost too. It made me wonder why they'd both closed and what one needs to do to keep these places running – what you need to do to stop them becoming redundant, or to make them be something again. It all seemed to come down to some idea of energy, so I knew I wanted to physically put some form of energy in the church again.*

On entering the vast interior of the church there was initially no sign of the energy that Wilson had brought to the building apart from a muffled rhythmic sound. Visitors to the space entered through a small rear door to be presented with a view up the empty body of the stripped-out church. Instead of the platform that would have supported the altar in the building's former life, however, visitors encountered a massive wall stretching from the floor to the roof some thirty feet above (fig.73). Fabricated from wooden struts and filled with thick wads of insulation, the wall separated the church into two volumes and was angled away from the entrance as if to compress the space in the hidden quarter of the building. At the bottom right-hand side, dwarfed by the huge scale of the wall, a standard door-sized hole allowed passage through to the other side.

The wall of insulation material was not simply a visual barrier but more importantly muffled the cacophony of sound that dominated the compressed volume of the altar area. Rounding the doorway, the visitor was assaulted by the drone of a fully functioning Lister Petter engine noisily converting diesel into electricity, competing with the equally overbearing sound of a drummer. The drumming came from the soundtrack of a film that was projected on a near-cinematic scale, thrown high onto the sloping back of the insulating wall by a video projector powered by the electricity that the diesel generator was producing (fig.74).

I took the idea of the social energy you need to sustain community spaces like the church and pool and made it physical. When I thought 'energy' I just thought engines, so I went and got a 10kva diesel generator and put it in the space. Then I started thinking 'Right, what can I do with this?' And I started to think of the swimming pool and I thought I'd link the two spaces by making a film that depicted a very different and human sort of energy and then bring that

to the church and use the generator to make the juice to show it.

When Wilson thought of human energy he immediately recalled the furious drumming marathons that were central to Bow Gamelan's performances. Although he had remained close friends with Paul Burwell, the two had not collaborated on a work together since the demise of the ensemble a decade earlier. As soon as Wilson had Burwell on board the final idea for the piece clicked into place.

I went to Paul with the idea that I'd build a platform or trolley and that we'd make a drum kit and mount it on it. Then we'd swing him around furiously inside the derelict pool while we filmed him playing the kit from a camera mounted onto the trolley. That meant that Paul would always be at the centre of the frame with the derelict environment of the swimming pool – this wonderful mix of really invasive, established undergrowth and the flaking blue of the swimming pool walls – flashing by behind him. I got him to play almost non-stop all day, frantically improvising to a tape of the sound of the generator playing over the sounds around the pool. By the end of the afternoon he had weakened; his energy had gone, so he couldn't sustain the performance. I edited the performance into the film for the church so that over its duration you see Paul failing, but the engine just pounds on regardless.

When the film was projected in the empty church, it formed a bridge between the two derelict spaces, linking them photographically. Burwell's performance – part duet, part duel with the generator – represents an oppressive and unequal symbiosis that he has no hope of sustaining. The critic Tom Morton recently described Burwell as 'All aviator sunglasses, frazzled hair, and middle-aged spread … a fading man practising a fading craft'.[1] He emphasised how Wilson's choice of his contemporary as human engine deepened the sense of physical juxtaposition with the seemingly endless mechanical energy of the generator, thus making the engine's dispassionate triumph seem that much crueller.

Turbine Hall Swimming Pool touches on ideas of physical dereliction, cultural and social redundancy, the effectiveness and validity of art as a tool for urban change, and the limits of individual human ability to oppose impersonal forces. In doing so it illustrates how Wilson's deeper awareness of social context has allowed him to create a complex physical metaphor for the decline of the communal and creative expression that accompanies the social deterioration inscribed in the physical decay of local communities.

[1] Tom Morton, 'Vault Face', *Richard Wilson*, exh. cat., Palazzo Delle Papesse / Gli Ori, Florence 2004, p.39.

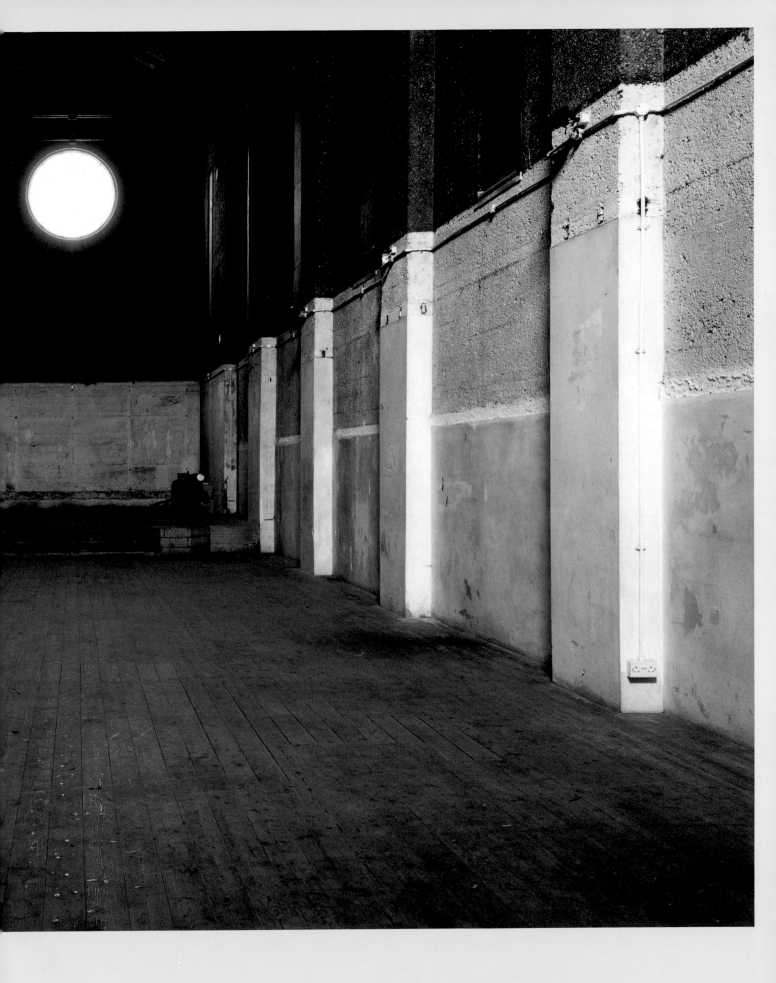

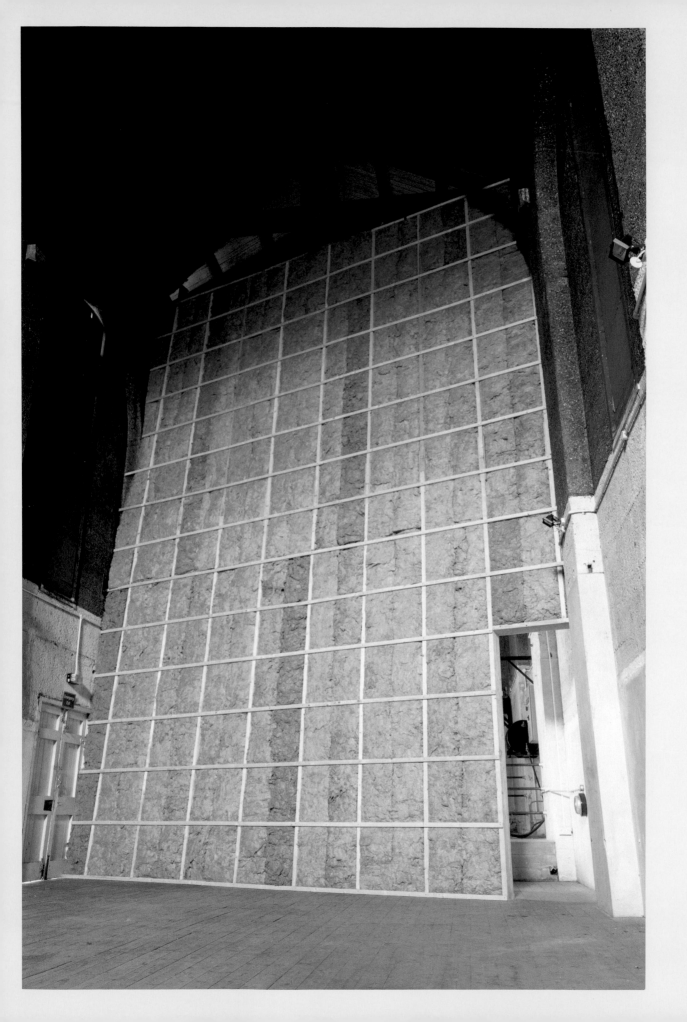

CORNER 1995 [75]
Table-football machine
80 x 80 x 100 (31 $\frac{1}{2}$ x 31 $\frac{1}{2}$ x 39 $\frac{3}{8}$)
Galleria Valeria Belvedere
British Council Collection

Gordon Matta-Clark
SPLITTING 1974 [76]
Cibachrome
70 x 100 (27 ½ x 39 ⅜)
Private collection

SCULPTING IN TIME

That *Turbine Hall Swimming Pool* joined its two sites temporally through the use of film rather than physically through some sculptural device at first appears to be a major departure from Wilson's established language. But although the incorporation of film into his installation marks a development in his artistic vocabulary, he had been considering the use of the moving image to embody and expand his sculptural ideas for some time.

Wilson had begun to contemplate utilising film in his work as early as 1993. In that year he was invited to propose an outdoor work to occupy the lawns outside the Serpentine Gallery in London's Kensington Gardens, to accompany a Gordon Matta-Clark retrospective inside the gallery. He immediately began to think about forms of temporary architecture, in keeping with his gallery-based installations at the time. Reflecting on the associations of parks and recreational spaces, he settled on the idea of using a prefabricated wooden sports pavilion, like the ones that stand next to village cricket pitches. The pavilion was to be cut and reconfigured, and a four-sided, squared-off cone of almost equal mass would be placed within it, so that its narrowest end would protrude from a rear corner of the structure and its widest end would explode through one corner at the front (figs.77–9). The structure itself was replete with references to Matta-Clark's work. The pavilion was reminiscent of *Splitting* 1974, the wooden house in a poor New Jersey suburb that Matta-Clark had cut into halves, tilting the back half away from the front by five degrees (fig.76). The squared-off cone carried echoes of *Conical Intersect* 1975, while the cutting was reminiscent of any number of the earlier artist's projects. To this, Wilson added a filmic element that could be seen to echo the counter-culture sensibilities of Matta-Clark's earliest performances and actions in the late

1960s, but reconfigured in an English idiom. Titling the work *Hyde Park Concert 2*, Wilson proposed to install a projector inside the cone so that one of its walls became a projection screen for footage of the legendary Rolling Stones concert held in neighbouring Hyde Park in 1969.

Although the work was never realised, *Hyde Park Concert 2* reveals the roots both for Wilson's attention to social or historical context, and for his use of film. However, it is important to note the way in which he was conceiving of film as a material at this juncture. In selecting a pre-existing piece of footage, he was treating film as a found element, like any of the physical materials he manipulated in his work – something from the real world with a particular set of resonances that he could utilise to his own ends.

The first time Wilson used his own film came in 1997 with *Ricochet (Going in/off)* 1997, made for the Château de Sacy, in Picardie (fig.84). Based on a French billiard table, the work revisited his interest in the spatial scenarios of table-games previously demonstrated in works such as *Corner* 1995 (fig.75), made to accompany *Cutting Corners* at Gallerie Valeria Belvedere, Milan. For *Corner*, Wilson cut a circular section from a table-football game and, mimicking the corner spot on a football field, mounted it in the corner of an otherwise empty room. The cut at once revealed the machine's internal workings and rendered the machine unplayable. More specifically, however, in its use of the billiard table and its reference to water, *Ricochet (Going in/off)* was a reconfiguration of *Watertable*. But rather than physically intervening in the fabric of the table and connecting it to actual water, *Ricochet (Going in/off)* manufactured an illusionary space. Installed in the games room of the château, the work utilised the existing billiard table and the three balls that comprise

Maquette for HYDE PARK
CONCERT 2 1993 [77]
Proposal for Serpentine Gallery,
London
Cricket pavilion, metal cone screen,
film loop of Rolling Stones concert
Dimensions variable

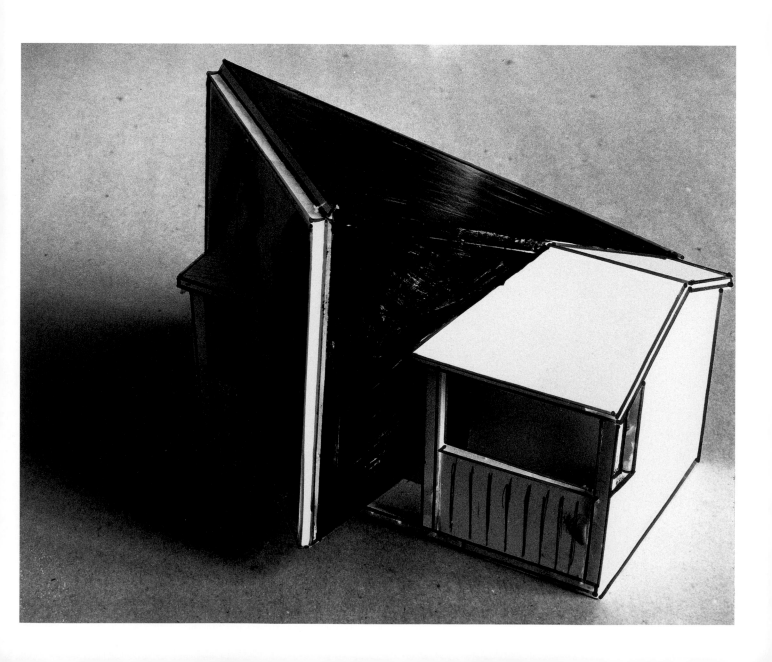

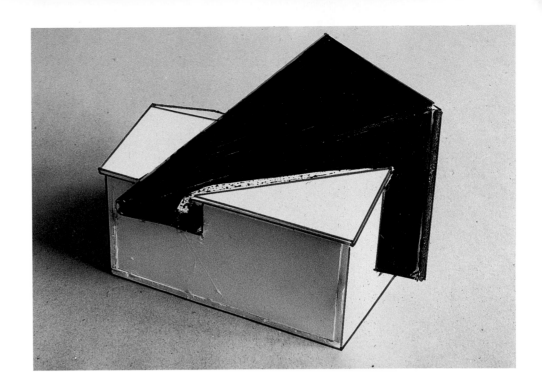

Maquette for HYDE PARK
CONCERT 2 1993 [78]
Proposal for Serpentine Gallery,
London
Cricket pavilion, metal cone screen,
film loop of Rolling Stones concert
Dimensions variable

Maquette for HYDE PARK
CONCERT 2 1993 [79]
Proposal for Serpentine Gallery,
London
Cricket pavilion, metal cone screen,
film loop of Rolling Stones concert
Dimensions variable

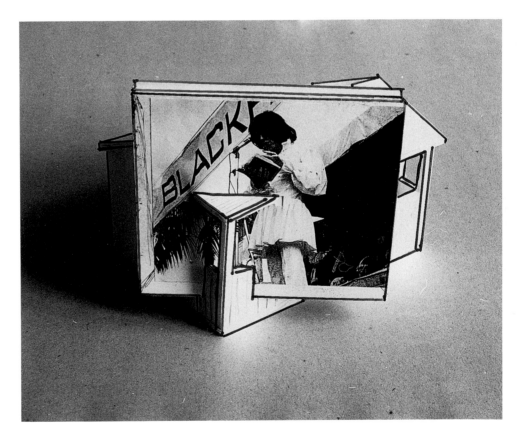

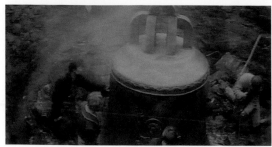

Still from ANDREI RUBLEV [80]
(directed by Andrei Tarkovsky, 1966)

Still from ANDREI RUBLEV [81]

the French game. Two customised stands held a 8mm film projector and a small, articulated mirror over the table. The projector played a film of a burst water main bubbling through the grass of Southwark Park in reverse onto the mirror and this was subsequently reflected onto the white billiard ball, creating the illusion that water was rushing into a hole in the ball.

Ricochet (Going in/off) and *Hyde Park Concert 2* both utilised film not only to displace an absent space into the one inhabited by the work, but also to displace a past moment into present time. This ability to shift the temporal and the spatial may be something we associate with the vocabulary of film but we do not readily connect it with the idea of sculpture. Writing in the catalogue that accompanied Wilson's recent commission for the Caveau at Palazzo delle Papesse, Sienna, Tom Morton stated how:

Wilson's factoring of film into his practice poses a set of philosophical problems. While both film and sculpture, in classical terms, inhabit three dimensions, these are not the same three dimensions. Both exist in length and breadth, but film knows nothing of volume, while sculpture knows nothing of time. Moreover, a film always presents us with pictures of the past, while a sculpture, empirically speaking, always presents us with a picture of the present (it can't help it, the present is where it lives).[1]

But although film has primarily been compared to the two-dimensional pictorial art of painting and the narrative concerns of literature during the twentieth century, there have been isolated voices that have conceived of film in relation to the three-dimensional. The Russian film-maker Andrei Tarkovsky (1932–1986), whose seminal works include *Andrei Rublev* (1966; figs.80–3), *Solaris* (1972), *Stalker* (1979) and *The Sacrifice* (1986), described his image-rich, nonlinear approach to cinematic narrative as 'sculpting in time'. Tarkovsky's concentration on what he

termed 'rhythm' – stressing the interconnectivity of the physical world and the temporality of the nonphysical – found echoes in the expansion of sculptural practice at this time into the idea of installation. Installation as a form encompasses a huge variety of permutations of material, content, effect and intent, but within this diversity some common factors can be identified. Primary amongst these is the idea that the work has moved from being object, through being object *in* space to become object and space, the division between what the artist creates and the space in which he or she exhibits it is eroded in installation, and despite the diversity of ways in which this is done, installations underline, to differing degrees, the fact that the apprehension of art is an act that is indivisible from the space in which it is apprehended.

This enlisting of the space in which art is shown as an active support, if not the actual fabric, of an installation means that the experience of the installation is therefore also dependent on the time span in which it is viewed. The space around art, even the often neutral container of the gallery, inhabits the temporal as we do as viewers, and like us it is affected by the constant flux of natural and social systems. Something as simple as the time of day at which an installation is viewed could significantly alter the experience of two visitors to one installation. The work is therefore 'sculpture in time', to make a noun of Tarkovsky's verb. It exists in four dimensions – in the three dimensions of the physical space it enlists and simultaneously in the fourth dimension of time, bringing the work of art fully within the dimensional reality that its viewers inhabit.

The function of time in Wilson's work is not hard to identify. It is present even in the early experiments with fire or with the elastic limits of material in his studio at Butler's Wharf and becomes firmly

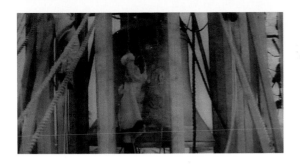

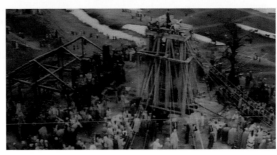

Still from ANDREI RUBLEV [82]　　　　　　Still from FROM ANDREI RUBLEV [83]

embedded within his installations. *Leading Lights* and *She came in through the bathroom window* were both fundamentally affected by the time of day at which they were seen. The draining of the swimming pool marked the passage of the exhibition in *Hopperhead*, while *One Piece at a Time* could only be understood in terms of the totality of its timeframe, the work actively comprising each crashing car part and each silence between them, its form mutating and evolving up until its final moment. Even something as static as *Slice of Reality* can be understood in terms of time: the sculpture pivots on the overt signalling of the cessation of the ship's previously useful function.

Since *Slice of Reality* and *Turbine Hall Swimming Pool*, ideas of both time and energy have become central motifs in Wilson's work and increasingly the artist has harnessed the moving image actively to infuse his work with their presence. The film *Bank Job* (fig.85), made in 2003 for Caveau, the oppressive basement space at Palazzo delle Papesse, Centro Arte Contemporanea in Sienna, places the viewer in the centre of a conflation of history, space and expectation that revolves around the space's status as a former bank vault. Descending the staircase, the visitor also descends into darkness, which conceals the cages and bars that describe the vault's previous life. At first this darkness is total, since the film itself begins in darkness. A few seconds pass before the flare of a struck match illuminates the screen: the artist lighting a fuse like those used to detonate explosives hanging down from the top of the frame in front of him. The fuse begins to burn, at first reluctantly and then more hungrily, allowing the viewer to see that the action is taking place outside at night, until the image disappears out of the frame. When the film quickly cuts, the fuse is now positioned horizontally. The viewer has only brief moments to recognise that the scene is

RICOCHET
(GOING IN/OFF) 1997 [84]
French billiard table, steel stands,
Super-8 projection, mirror, three
billiard balls
300 x 150 x 150 (118 x 59 x 59)
Château de Sacy, Picardie

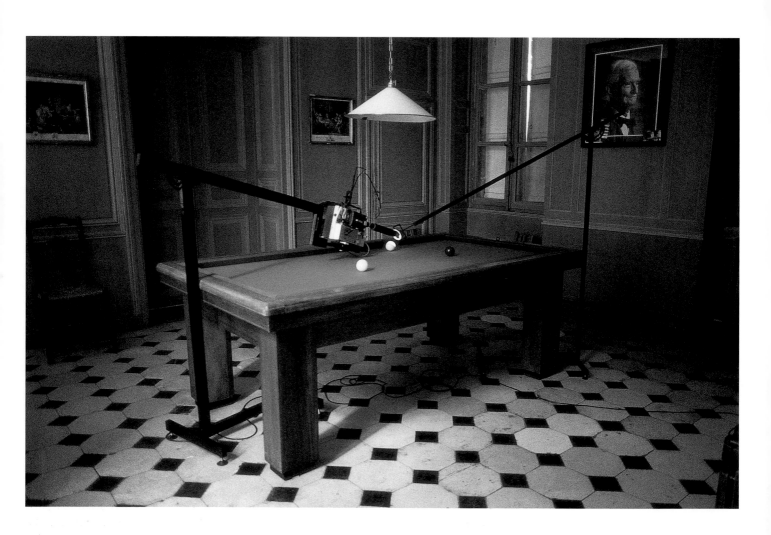

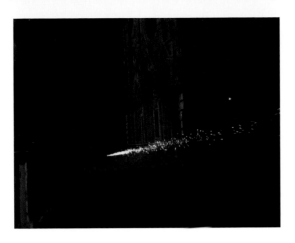

Still from BANK JOB 2003 [85]
DVD projection, screen, sound system
Palazzo delle Papesse, Sienna

that of a semi-rural street, before the fuse, magically suspended in mid-air, begins to behave more like a rocket than the slow-burning devices we may recognise from heist films or cartoons, shooting off at break-neck speed. The film traces the physical passage of the fizzing fuse, racing forwards from its starting position at the rural edge of the suburbs towards Sienna's city centre and the Palazzo delle Papesse, building into a breathlessly snatched portrait of the twisting streets of the city. The viewer then sees the fuse entering the Palazzo like some rapid-fire memory burst, its frenetically edited passage creates a conflagration of its own, a filmic explosion that devours the building through which the viewer has just moved.

At its zenith, however, the film's expression of time and its passage through space is radically inverted. Rather than showing the fuse detonate an explosion, the film instead atrophies, grinding to an almost total halt under the burden of a reversed and distended soundtrack. Instead of the expected explosion, the viewer is presented with its smokey aftermath, but this quickly disappears, to be replaced by a briefly glimpsed image of the vault entrance, before darkness and the sound of a heavily slammed door from speakers placed behind one's head enfold one in what Wilson has described as 'a lie and a reversal. Not the expected "breaking in" associated with explosives and bank vaults but an illusion of incarceration created with the same material.'

Wilson has stated that he employs film to introduce 'second-hand, past-tense information' into his work. Whereas in *Bank Job* this past-tense information is used to magnify and then manipulate the viewer's expectation of the site's inherent narrative, in other recent works film has been used to destabilise our assumption that a present object occupies a posi-

tion that is superior, both in terms of a temporal and artistic hierarchy, to film's document of past time. The drawing for *Strange Apparatus* 1999 underlines the evolution of these ideas (fig.86). Describing two adjacent spaces, the drawing outlines an intriguing scenario comprising a peculiar system composed of everyday equipment in one space and a film being projected in the room next door. Wilson's proposed connected system of familiar objects, from lawnmowers to bicycle wheels to car fan-belts, bears a similarity to the unstable system of domestic items that create the absurd but riveting chain reaction in the seminal film *Der Lauf der Dinge* (The Way Things Go) 1987 by the Swiss artists Fischli & Weiss (fig.87). But whereas the objects in Fischli & Weiss's film simultaneously describe a system and its instability, Wilson's system appears to have a purely functional end, seemingly rigged-up to form a circuit that generates electricity to power the film projected next door. The film that is being shown apparently depicts the very equipment that is providing its power source, creating a closed loop of the documented present. But in fact it is an educational film found at a car-boot sale, not a live record of the generating system next door. The equipment used to power the film has been sourced to replicate the documented system, so that the expected temporal hierarchy is inverted – the film being the generator of the sculpture rather than its document.

Traces of *Strange Apparatus* imbedded themselves in the symbiotic, elliptical relationship between the human and mechanical generators in *Turbine Hall Swimming Pool*, with its displaced relationship between past and present time. But it is in *Butterfly*, made for the Wapping Project, London, in 2003, that Wilson's exploration of the hierarchies surrounding film and sculpture has been most concretely located.

Drawing for STRANGE APPARATUS 1999
[86]
Ink and watercolour on paper
Collection of Simon Morrissey

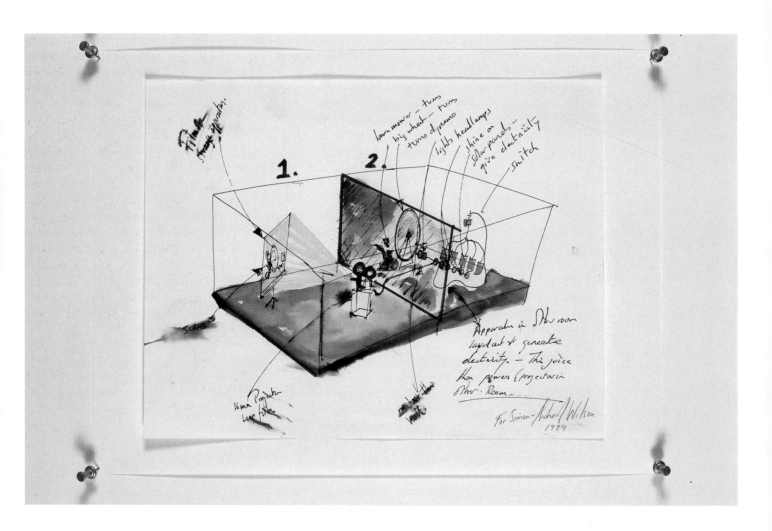

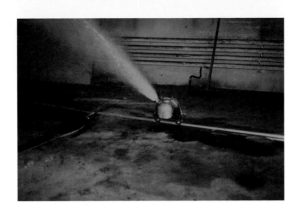

Peter Fischli David Weiss
THE WAY THINGS GO 1987 [87]
16 mm, colour, 30 minutes

For this work he bought a scrapped Cessna light aircraft, reassembled it, stripped its identifying paint-work from its aluminium body then crushed it into a rough ball. The inarticulate volume that resulted from this process, disguised by the crushing, was then suspended from the ceiling of the Wapping Project. Wilson and a team of helpers worked for four weeks under the gaze of gallery visitors using only hand-operated tools, straps and the structure of the build-ing itself to help them re-form the crushed husk of the machine back into its original shape. Although this would appear to inform the work with an idea of art's redemptive power to transform the lost or lowly, as Richard Dorment stressed when writing on the work for the *Daily Telegraph* in 2003, Wilson 'knows that in real life there is no such thing as resurrection from the dead'. Once the now recognisable plane had been returned as near to its original shape as the team could manage by hand, it was manhandled out of its central suspended position between four pillars in the gallery and crashed to the ground at the rear of the space. A large screen was then suspended from the ceiling opposite the entrance to the space, almost concealing the plane in the now darkened gallery. The recovery process had been continuously documented by time-lapse photography and this film, edited to document the unfurling of the plane's restoration in compressed time, was projected onto the screen.

In dumping the object of so much concentrated effort so decisively and then obscuring the plane itself with the screen, *Butterfly* foregrounded the docu-mented process of the plane's transformation alluded to in its title over the object itself. This appeared to confer superiority onto the film, and by default onto the absent process, rather than onto the sculptural object, the recovery of which was the apparent point of the entire laborious process. The history of the process demands the viewer's attention, suppressing the present object. Yet *Butterfly*'s position with-in such a hierarchical discourse is complicated. Watching the film the viewer slowly becomes aware of the looming presence of the discarded plane, sitting bolt upright on its broken nose behind the screen. The polished surface of the battered aluminium body reflects fragments of the film, making it a beguiling presence. It is physically there and yet inert. The past, however, is materially absent yet visually active. Film and object give the impression of leaning on each other, neither being able to fully embody the process that gave birth to them, and thus to support the idea of the work in isolation. The plane is only animated by the film's record of its past, and in gaining physical foundation in the object that it documents, the past of the film stretches time to gatecrash into the present, resulting in a sculpture that only truly exists within a dialogue between past and present time.

[1] Tom Morton, 'Vault Face', in *Richard Wilson*, exh. cat., Palazzo delle Papesse, Centro Arte Con-temporanea, Sienna 2004, pp.39–42.

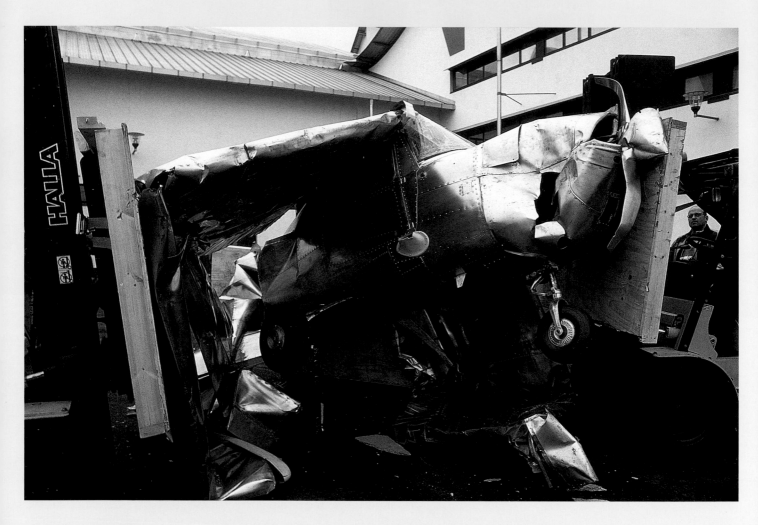

BUTTERFLY 2003 [88]
Preparing for the exhibition

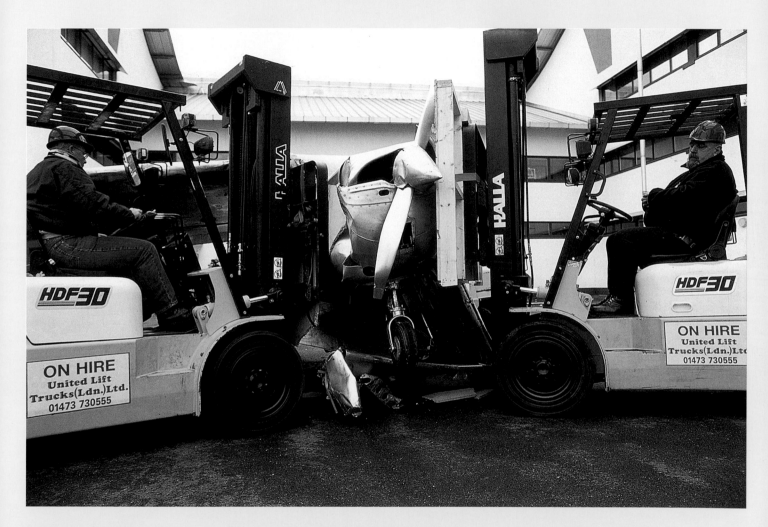

BUTTERFLY 2003 [89]
Preparing for the exhibition

SIMON MORRISSEY Butterfly seems to be the outcome of a certain restlessness that makes you continually re-examine the parameters of your work. Can you tell me where the initial idea for the piece came from?

RICHARD WILSON *In a sketchbook from about two years ago I found a scribble on a page with the instruction 'Take an object – crush it – pull it out again.' When I saw the Wapping Project space I knew that this idea was a contender for the piece I might make there because I could immediately see that I could use the interior structure as a mountain climber uses a rock face. I could 'pull out' an object using the building as a structure to anchor onto. The idea was always about pulling something back into shape rather than crushing it. It's like finding a five pound note in the pocket of your jeans after they've been through the washing machine and trying to unfurl it again – what is the act you're performing in pulling that note straight, in trying to reclaim it? It was only as I played with the idea and tested it out that the idea of the plane emerged as the object to be reclaimed. A lot of that's to do with relying on a gut feeling, on trusting your instinct about what's the right direction for the idea to take. I settled on the plane because it's not an earthbound form; it's something we associate with being suspended in the air rather than inside a building. The idea of the plane, fastened so that it was suspended in the space, seemed like it could represent some kind of frozen moment.*

SM In your interview with Lynne Cooke published when you made *Heatwave* at Ikon Gallery almost twenty years ago, you said that you 'didn't believe in process as perform-ance'. It would be tempting to think that *Butterfly* marked a retraction of that statement, since the act of recovering the plane was carried out in front of the public.

RW *I don't see the recovery process as a performance at all. Nothing was dramatised; there was no planning or emphasis on the way we conducted ourselves or the task at hand, and no real framing of it as an event either. It was more of a case of using the space at Wapping as the studio to build the work. It was very pragmatic about the way it unfolded. What was done was that which needed to be done to accomplish the task I'd set the team; nothing else. I wasn't trying to emphasise the act of recovery, but rather attempting to find out where the work would emerge and where that would take me. Although I had certain parameters in* Butterfly, *like the recovery of the plane and the fact that that act would be documented, I allowed myself to begin it without a set idea of how those elements of the work would finally be configured. There's a long history of working on site in my work. The only difference with* Butterfly *was that I made that process available to the public, so that initially the creative act of recovering the plane might appear to be the work itself. It didn't feel unfamiliar to me to be in a gallery building. For me the spaces in which I make work are the test beds for my ideas. In* Butterfly *I*

Marcel Duchamp
THREE STANDARD
STOPPAGES
1913–14 [90]
Assemblage: three
threads glued to
three painted canvas
strips, each mounted
on a glass panel, three
wood slats, contained
in a wooden box;
overall size
28.2 x 129.9 x 22.7
(11 ⅛ x 50 ⅞ x 9)
The Museum of
Modern Art, New York.
Katherine S. Drier
Bequest

suppose I just let the public in early to watch the experiment so that they could ask themselves the same question I was asking: 'What makes a sculpture?'

SM You also said that one of the first pieces that excited you was Duchamp's *Standard Stoppages* (fig.90). In its foregrounding of process *Butterfly* seems to relate directly back to these first enthusiasms. Does it connect to *Standard Stoppages* in your mind?

RW *Process has always been exciting to me – how a form becomes real in the world of forms. But I've always played this evolution out through recognisable objects, not on forms that I've invented. I think that relates really closely to* Standard Stoppages. *Duchamp simply dropped pieces of string to make a work that was able to talk about ideas of time and change. He based those ideas in recognisable material from a world of pre-existing forms. In Butterfly the plane is like Duchamp's string. In recovering the plane we simply copied the form set out in the material already, just like if you smashed a cup and then tried to glue it back together again. The form of the pre-existing material dictates the form of the work.* Standard Stoppages *remains string and* Butterfly *remains a plane, but new ideas are played out across it. Both works directly embody ideas of time and translation and in doing so find new ways of logging actions.*

SM When you started *Butterfly* Lynn MacRitchie wrote that you were 'motivated by a continuing curiosity, a need to interrogate complicated things'. Is that curiosity just about interrogating things in the world or about testing your own assumptions of what it is you do as an artist as well?

RW *I saw Butterfly very much as an opportunity to rejuvenate my thinking. I deliberately allowed myself to be in a situation were there was an aim but no predetermined conclusion. I'm not interested in falling into playing safe and just doing what I know I can do. I think the emergence of film as a more and more important factor in my recent work is a reflection of that. I've always been interested in what's unknown to me, so each new work must include an element of uncertainty. Attempting to create what you cannot predict is the extreme act of creativity. So to return to your first question, yes I suppose Butterfly was really pushing what it is that I do as a sculptor. Because I carried it out in public it was a one-shot deal. I had no idea how the piece was going to work out, as the completion of each task influenced the progression of the direction of the work. What excited me with Butterfly was the notion that the work revolved around this completely failed situation – attempting to unfurl a crushed plane – and that failure could have spilt over into the work, and it could have come to nothing. That uncertainty and risk was very stimulating for me. That's what I find exciting about art – what it has to be for me. Attempting something I don't know about is what educates me.*

BUTTERFLY 2003 [91]
Crushed Cessna light aircraft,
hawsters, strops, ratchet straps
Wapping Project Space, London
Work in progress

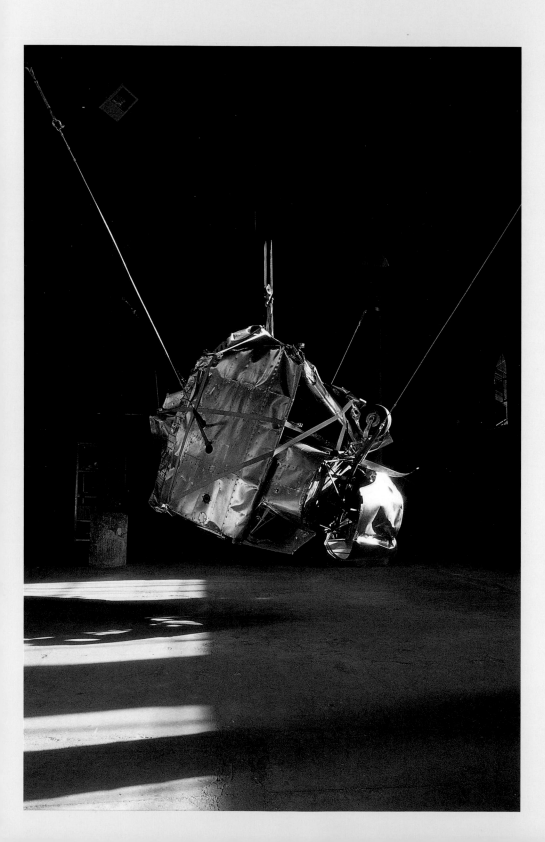

BUTTERFLY 2003 [92]
Crushed Cessna light aircraft,
hawsters, strops, ratchet straps
Wapping Project Space, London
Work in progress

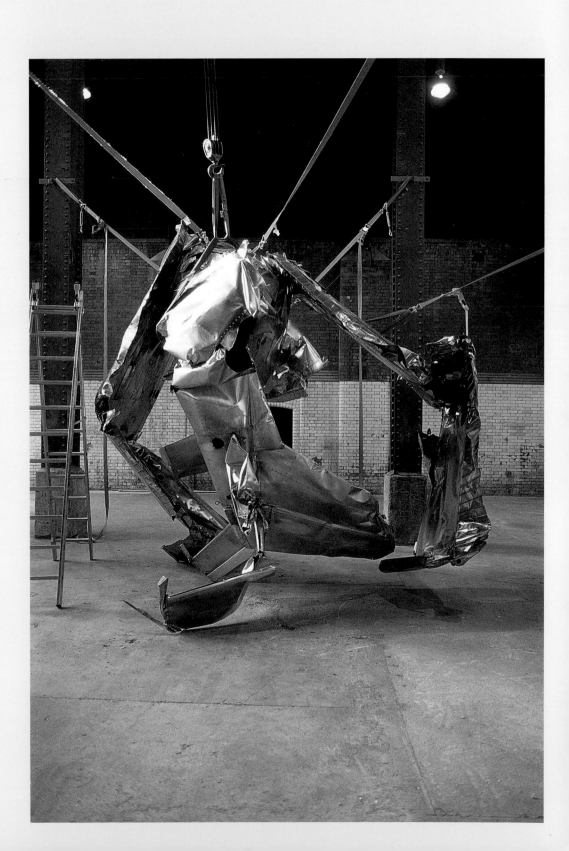

BUTTERFLY 2003 [93]
Crushed Cessna light aircraft,
hawsters, strops, ratchet straps
Wapping Project Space, London
Work in progress

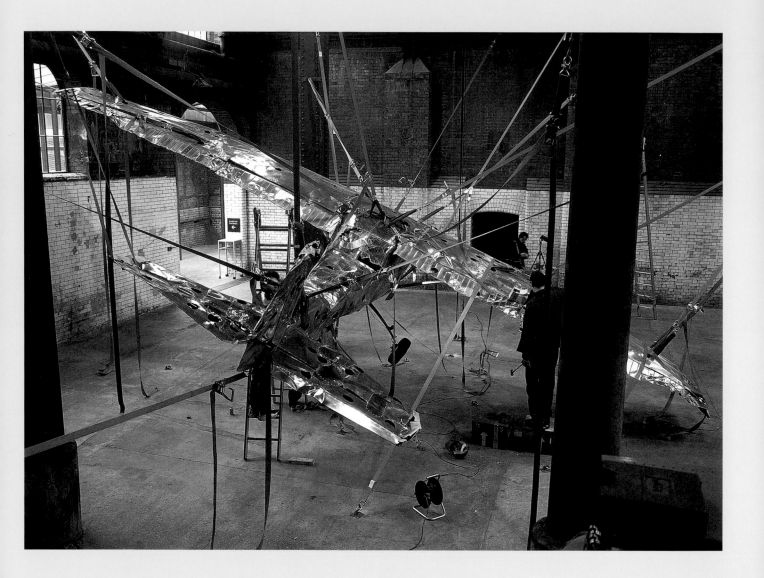

BUTTERFLY 2003 [94]
Cessna light aircraft,
488 x 366 (192 x 144) steel screen,
DVD, projector, spotlight
Wapping Project Space, London
Final configuration

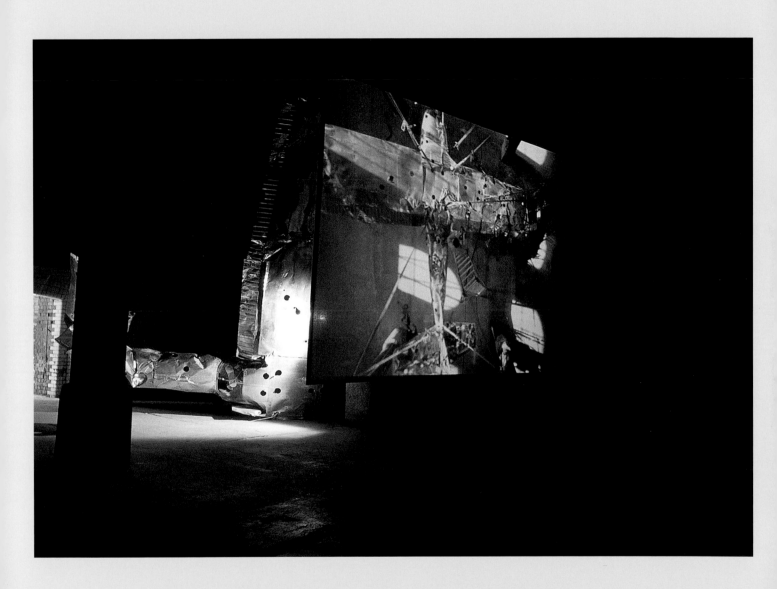

When talking to Richard Wilson about his work one word comes up again and again. He uses it without particular emphasis, but it is peppered throughout his conversation about his ideas and working processes. It is not a word one readily associates with the discussion or function of art, but recently it has begun to make an increasing appearance in the critical discussion of both art and other disciplines. It is a word that carries connotations of frivolity, yet it underpins Wilson's renegotiation of the received order of our environment and the energetic questioning that draws so many people to his work. The word is 'play'.

To most people play represents a certain set of values. It is primarily associated with children, and thus when it is transposed to the sphere of adult activity this primary association confers notions of an absence of serious purpose. Play is what we do as children, and when we are adults play is pleasure, escapism, abandon, even childishness. Or else it is associated with the idea of sport or the recent explosion of gaming culture. It is of particular note that when the idea of play has been brought into recent critical discussions of art it has primarily been used in a way that reflects our popular conception of the term, being set in relation to art that appropriates the structures of game playing or whose aesthetics and manufacture ape a child's artlessness.

Yet play has not always been understood in this way. The Indo-European root behind the Old English *plegian* – a root also found in Celtic, Germanic and the Slavic languages – is *dlegh*, meaning 'to engage oneself'. This notion of play as engagement, a term that denotes concentrated mental focus, is the antithesis of what have become the word's colloquial connotations. Play functions in this way historically within philosophy. The eighteenth-century philoso-

phers Emmanuel Kant and Friedrich von Schiller in their respective works *Critique of Judgement* (1790), and *Letters on the Aesthetic Education of Man* (1795) both situated play as a central agent within their theories of aesthetics. In these discourses, rather than representing the absence of constructive purpose, play was instead interpreted as the way in which we familiarise ourselves with and then master the complexities of our world, and ultimately fashion them to our ends. Schiller argued that play was a fundamental human drive that united sense and reason and was therefore the root of free will, and could even be the force that could establish true political freedom. Kant and Schiller established a ground upon which play is associated not only with aesthetics but also with the development of consciousness and morals, and seen as fundamental to our concepts of freedom and the limitations of human agency – or more precisely, our perception of the lack of them. During the mid-twentieth century play's relationship to art was again brought into discussion by the historian Johan H. Huizinga in his influential book *Homo Ludens: A Study of the Play Element in Culture* (1938). Huizinga's thesis borrowed heavily from Schiller to argue that play was in fact the very generator of culture. And although Huizinga's arguments had an important impact on artists like the Situationists, the idea of play as an important agent in human activity gained little widespread recognition during the twentieth century.

But if play is such an important concept, how and when did it become so trivialised? Since the late 1990s the Scottish social commentator Pat Kane has written a number of articles and essays exploring the ways in which the concept of play has been debased and marginalised by forces institutionalised in the growth

of industrial capitalist society, culminating in his book *The Play Ethic* (2004). Framed against the impending social and economic crises that are currently being heralded at a time when manufacturing, new technologies and globalisation are bringing the industrial age to an end in the West, Kane has attempted to draw diverse theoretical concepts of play into mainstream discussion in order to posit the idea of a 'play ethic' to replace industrial capitalism's 'work ethic'. In doing so he has outlined the social framework that brought about the marginalisation of the idea of play.

The Industrial Revolution required huge numbers of workers, carrying out repetitive, unfulfilling tasks, to keep the wheels of industry moving. The need of the capitalist classes to discipline its workers, dragged from the often meagre but varied life of rural self-subsistence into the punishing and monotonous regimes of factory labour, were ensured in two ways. Throughout the eighteenth and nineteenth centuries the 'Protestant work ethic' – which held that hard work was analogous with virtue – used religion to instill obedience and conformity in the workforce, while the idea of play was repackaged as 'leisure' and 'entertainment'. These were compensations for the hardship of work – non-work rather than activities in their own right. Firmly corralled into tiny pockets of time in a worker's life, the ideas of leisure and entertainment were part of, rather than a challenge to, the excessive regimentation required by the industrial age, despite their potential for excess and frivolity. The rhetoric of the capitalist establishment and the church relegated the idea of play to an infantile, indulgent state of being that all serious and pious adults must put behind them.

These values have remained surprisingly intact in industrialised society even up to recent times. Work confers value, self-esteem and social status more than any other social indicator, while leisure and consumption have become the opiate of the masses and play is still the opposite of the serious. Yet Kane draws our attention to the fact that economic commentators are ringing alarm bells, warning us that recent technological advances are set to present the Western value system with a fundamental challenge – the end of mass wage labour. Governments face the prospect of mass unemployment triggering an epidemic of depression, social division or even disintegration unless they plan to structure society on a foundation other than work.

Kane draws on a wide range of academic theory about the nature and role of play that has recently been emerging in spheres as diverse as biology, psychology, education, metaphysics, mathematics and sociology, and fuses this with an investigation of alternative models to traditional notions of employment offered by activism, counter cultures, continuing education, entrepreneurship and art to call for an understanding of the true meaning of play and for this in turn to form a new foundation for citizenship. Play replaces the involuntary necessity and regimentation of work and the vacuous compensations of leisure with a structure that is voluntary in motivation and characterised by creativity, experiment and innovation. Play is not leisure but a pursuit entered into freely, creatively and responsibly. Thus meaningful work and serious play are the same thing.

Play can be understood as a philosophical stance through which activity is approached. For Wilson, it represents the challenging of the received order, but one that is defined as the place where exploration intersects with personal responsibility:

Still from DOMELESS
IN SEATTLE [95]
The blowing up of the King Dome in Seattle

EARTHQUAKE PAVILION 2004 [96]
Photo collage and paint on paper

ity that can reconfigure them so definitely? The answer is a fascination with displacements of the received order of our environment – be that man's attempts to master material in order to exert dominion over the natural world, or the natural world's often visceral reassertion of the fragility of that dominion. Wilson draws equally on the apparently random juxtapositions created by disasters and on the peculiar possibilities of engineering to subvert our most basic assumptions of order, to instill the idea of our world turned upside down. His library is dominated by an eclectic collection of depicted displacement: *The Hurricane and Flood of September 21, 1938 at Providence, R.I: A Pictorial Record*; *Die Flutung des Berliner S-Bahn-Tunnels*; *God's Own Junkyard: The Planned Deterioration of America's Landscape*; *Train Wrecks for Fun and Profit*; *Atmosphere, Weather & Climate*; *Brunel's Tunnel ... and Where it Led*; *The Book of Heroic Failures*; *The World's Greatest Cranks and Crackpots*; *Isambard Kingdom Brunel*; *921: Retrospective Silhouette of Taiwan's Earthquake*; *Engineering Wonders of the World*, vols.I and III; *Speed: The Authentic Life of Sir Malcolm Campbell*; *Disaster!: One Hundred Years of Wreck, Rescue and Tragedy in Scotland*; *Theory of Machines*; *A Picture History of the Brooklyn Bridge*; *Breakthrough: Tunneling the Channel*; *Structural Steelwork*; *How Things Work: The Universal Encyclopaedia of Machines*, vol.2; *Ten Thousand Wonderful Things*; *The Oilwell Engineering Co. Ltd Catalogue No.26*; *Your Book of Industrial Archaeology*. These books provide a visual inventory of material rearrangement that underpins Wilson's sculpture (figs.97, 98): a hurricane's pathway where houses have been uprooted and landed in fields on their heads; huge ships broken in half on coastlines or deposited on land by storms; vast tunnelling devices large enough for hundreds of workers to pose within for photographs; cores drilled miles into the earth to test for oil. But Wilson's application of these disruptions to the familiar order of architecture and machines is particular because of the very nature of the origin of that order. Despite his admiration for Land artists such as Walter de Maria or his enthusiasm for works like Barry Flanagan's precariously maintained *Hole in the Sea* 1969 (fig.100) – where the artist pressed a small Plexiglas cylinder into the sand off the coast of Holland and filmed the incoming tide increasingly identifying the void until eventually engulfing it – Wilson has stated that he has no interest in making work with the natural landscape. He returns again and again to architecture, industrial processes and machines because they are obviously man-made, and thus clearly denote systems that we have created for ourselves to exist within. His traffic between the familiarity of the material he uses, the unfamiliarity of the application he brings to bear upon it and the resulting image or situation can be read as an explicit example of serious play. His sculpture is not an attack on a system from without but a reconfiguration from within, and the implication is that the systems we may choose to view as fixed are in fact malleable if we have the will to make them so.

Wilson has taken inspiration for this spirit of enquiry from the extreme physical play of inventors and engineers throughout the nineteenth and twentieth centuries. These include Isambard Kingdom Brunel, who frequently pushed experiment to the point of disaster before achieving success, and Thomas Sopwith, who once described the secret of a career spanning the design of the Sopwith Camel in 1916 and the Harrier Jump Jet in 1960 as being attrib-

Robert Morris
INSTALLATION AT THE TATE GALLERY,
LONDON 1971,
with participants [99]

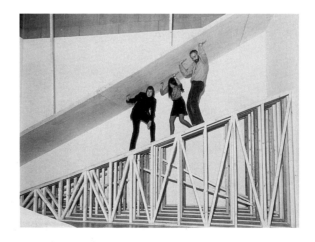

utable to the fact that he 'made friends' with each new problem that presented itself to him. Like them, Wilson restlessly reconfigures the parameters of his practice, not just the parameters of the material with which he works. He finds the idea of falling into formal repetition an anathema, as well as disliking the imposition of labels on his practice that may pigeon-hole his activity and create expectation and thus limitation. He does not describe himself as a 'site-specific artist' or an 'installation artist'. If he were to label himself it would be as a 'sculptor', a term that he feels more accurately describes his primary engagement with the world of material, objects and space but which does not prescriptively describe how that engagement may manifest itself. And even under the banner of such a term he feels no obligation to work only with three-dimensional objects, as the recent adoption of film as a central tool in his practice has shown.

Wilson's antipathy to formulas and his conscious evasion of a fixed style or manifestation in his work are indicative of his conception of art as a continuously evolving enquiry that redraws its parameters with the execution of each new step – the very antithesis of regimentation and conformity. This is reflected in the fact that he has often expressed a disappointment that verges on incomprehension regarding artists who settle into a fixed formula in their art. In conversation with the critic Ossian Ward in *Art Review* in 2003, he was characteristically outspoken: 'It is so tired and boring seeing good artists producing shit because they have a little bit of success with an idea and it has just been rehashed.'[1] He does not see it as the artist's job to produce a recognisable product for easy consumption, but rather to challenge such categorisation, stimulating us to look

Barry Flanagan
A HOLE IN THE SEA 1969 [100]
Plexiglas tube inserted into the sea,
Holland

Chris Burden
SAMSON 1985 [101]
Turnstile, winch, worm gear,
leather strap, timbers, jack, steel
and hardware
Dimensions variable
Installation Henry Art Gallery,
University of Washington, Seattle

again at our world, to test our expectations, not to confirm them.

In succumbing to the external pressure to conform to type it could be argued that such artists have imposed the structures of involuntary labour on an arena that should define itself against these pressures, thus negating art's potential. Art and the idea of play share fundamental characteristics such as the idea of self-governed enquiry and the experimentation with and transcending of prescribed rules about the world around us. Those artists with whom he shares this assessment are affectionately referred to as 'allies'. But he noticeably demonstrates more of an affiliation with the work of art than with the artist who made it. For example, when discussing Minimalism, he focuses not on Robert Morris's body of work as a whole but on his exhibition at the Tate Gallery in 1971, which, while resembling his signature sculpture, pushed both his own and the Tate's conception of how that sculpture was to function by explicitly inviting the public to climb on and use his structures, literally to play with them rather than look at them (fig.99). Similarly, Flanagan's *Hole in the Sea*, undoubtedly one of Wilson's favourite works, was a fundamental influence on installations such as *Watertable* and *Butterfly*, but he has no interest in the artist's later sculpture. And although he feels great kinship with the work of Chris Burden and Gordon Matta-Clark, he is more likely to discuss individual works such as Matta-Clark's *Splitting* 1974 (fig.76) or Burden's *Samson* 1985 (fig.101), for which the artist installed a 100-ton jack, gearbox and turnstile in the Henry Art Gallery, Seattle, which threatened the building by pushing two immense timbers against the load-bearing walls of the gallery each time someone entered the exhibition. This is because Wilson's instinctive engagement with the philosophies of play creates specific values. His admiration for these artists is two-fold – he admires the artist whilst their enquiry remains truly open, and he admires the works to which this philosophy gives birth. And although maker and work are obviously linked, Wilson understands that once in the world these works exist on their own terms and are not dependent on the nature of the artist's continuing activity. For him, art holds different satisfactions for its different participants. For the audience the satisfaction is in the reception of the work of art. But for the artist the satisfaction is in the continual enquiry, the play of art. Only through this play can the work of art emerge into the world to embody the artist's enquiry with any real meaning. Because to Wilson, meaningful work and serious play are one and the same.

[1] Ossian Ward, 'Flight Path', *Art Review*, April 2003, p.74.

Biography

1953	Born London
1970–1	London College of Printing (Foundation)
1971–4	Hornsey College of Art (Dip AD)
1974–6	Reading University (MFA)
1983	Formed the Bow Gamelan Ensemble with Anne Bean and Paul Burwell
1999–	Member of Artistic Records Committee, Imperial War Museum, London
2005–	Visiting Research Professor in Sculpture at University of East London

Selected Awards

1977	Boise Travel Scholarship (Venice, Florence, Sienna, Pisa, Paris), Arts Council Minor Award
1978	GLAA Project Award
1979	GLAA Project Award
1981	GLA Project Award
1988	Nominated, The Turner Prize
1989	Nominated, The Turner Prize
1992–3	DAAD Residency, Berlin
2003	Maeda Visiting Artist, The Architectural Association, London
2002–4	Henry Moore Fellowship in Sculpture, University of East London
2002–5	Paul Hamlyn Foundation Award to Visual Artists

Selected Solo Exhibitions

1976	*11 Pieces*, Coracle Press Gallery, London
1978	*12 Pieces*, Coracle Press Gallery, London
1983	*Viaduct*, Aspex Gallery, Portsmouth
1985	*Sheer Fluke*, Matt's Gallery, London
	Hopperhead, Café Gallery, London
1986	*Stoke Stack Lightning*, Stoke Garden Festival Commission, Stoke on Trent
	Halo, The Aperto, Venice Biennale
	Heatwave, Ikon Gallery, Birmingham
1987	*20:50*, Matt's Gallery, London
	One Piece at a Time, Tele-South-West Arts 3D National Exhibition (TWSA 3D), South Tower, Tyne Bridge, Gateshead
	Up a Blind Alley, Trigon Biennale, Graz
	Hot, Live, Still, for *Art in Action*, Plymouth Art Centre
1989	*Leading Lights*, Kunsthallen Brandts Klaederfabrik, Odense
	Sea Level, Arnolfini, Bristol
	High-Tec, Museum of Modern Art, Oxford
	She came in through the bathroom window, Matt's Gallery, London
1989–91	*High Rise*, São Paulo Biennale; UK/USSR, The House of Artists, Kiev and Moscow; Saatchi Gallery, London
1990	*All Mod Cons*, for *Edge 90*, Edge, Newcastle upon Tyne
	Takeaway, Centre for Contemporary Art, Warsaw
1991	*Face Lift*, Saatchi Gallery, London
	Lodger, Galleria Valeria Belvedere, Milan
1992	*Swift Half* and *Return to Sender*, Galerie de l'Ancienne Poste, Calais
1993	Installation, Kunsterhaus Bethanien, Berlin
1994	*Watertable*, Matt's Gallery, London
	Butler Gallery, Kilkenny Castle
	Deep End, for *LA/UK*, Museum of Contemporary Art, Los Angeles
	Galerie Klaus Fischer, Berlin
	Galleria Valeria Belvedere, Milan
1996	*Hotel: Room 6: Channel View Hotel*, Towner Art Gallery, Eastbourne
	Formative Processes, Gimpel Fils, London
	Jamming Gears, Serpentine Gallery, London
1997	*Ricochet (Going in/off)*, Château de Sacy, Picardie
1998	*Hung, Drawn and Quartered*, Stäädtisches Museum, Zwickau
	Drawings, Otto Dix Haus, Gera
	Irons in the Fire, Globe Gallery, South Shields
	Tate Christmas Tree, Tate Gallery, London
1999	*Hung, Drawn and Quartered*, Ha'Mumche Gallery, Tel Aviv
	Pipe Dreams, Architectural Association, London (collaboration with After Image)
2000	*Turbine Hall Swimming Pool*, Clare College Mission Church, Café Gallery Projects, London
2001	*Set North for Japan (74 ° 33" 2')*
	Drawings, Gimpel Fils, London
2002	*Irons in the Fire*, Mappin Gallery, Sheffield; Leeds Metropolitan Gallery; Talbot Rice Gallery, Edinburgh
2003	*Irons in the Fire*, Wapping Project, London
	Butterfly, Wapping Project, London
	Rolling Rig, De La Warr Pavilion, Bexhill-on-Sea
2004	*Bank Job*, Palazzo Delle Papesse, Sienna Program Gallery, London
2005	*Exit*, Storey Gallery, Lancaster
	Break Neck Speed, Yokohma Trienniale

Selected Group Exhibitions

1975	*The London Group*, Camden Arts Centre, London
1976	Whitechapel Open Exhibition, Whitechapel Art Gallery, London
1977	*Miniatures*, Coracle Press Gallery, London
1978	*Coracle Press in Amsterdam*, Galerie da Costa, Amsterdam
1979	*Sculptural Views*, Waterloo Gallery, London
1980	*Wind Instruments*, Coracle Press Gallery, London
	Portsmouth/Duisberg Link Exhibition, Lehmbruch Museum
1981	*Romance Science Endeavour*, Portsmouth City Arts Gallery
	Bookworks, Southhill Park Arts Centre, Bracknell
1982	*Paper Works*, Aspex Gallery, Portsmouth
	South Bank Show, Coracle Press Gallery, London
1983	*Pagan Echoes*, Riverside Studios Gallery, London
	Clifftop Sculpture Park, Portland, Dorset
	Four Artists, Galerie Hoffman, Friburg
1984	*British Artists Books*, Atlantis Gallery, London
1986	*Sculptors Drawings*, Ikon Gallery, Birmingham (and touring)
	The Elements, Bookworks, Milton Keynes (and touring)
1987	*Art of our Time*, The Saatchi Collection, The Royal Scottish Academy, Edinburgh
1988	*Made to Measure*, Kettle's Yard, Cambridge
1991	Saatchi Collection, London
1992	La Casa di Alice, Gallery Mazzocchi, Parma
	Not too clear on the viewfinder, IXth Sydney Biennale
	Another World, Mito Foundation, Tokyo
	Heatwave, Serpentine Gallery, London (collaboration with Paul Burwell and Anne Bean)

1993	*A Space without Art*, Fernsehturm, Berlin
	On Siat, Museet for Samstidskunst, Oslo
	Private, Kunstwerk, Berlin
	The Boatshow, Café Gallery, London
	Time Out Billboard Project, London
1994	*Art Unlimited: Artist's Multiples*, National Touring Exhibitions
1995	Mitzpe Ramon Co-Existence Project, Israel
1996	*A Matter of Facts*, Kulturamt Munster
	Mirades (sobre el Museu), D'Art Contemporani, Barcelona
	Islands, National Gallery of Australia, Canberra
1997	Dexion 50th Anniversary Sculpture Commission for NEC, Birmingham
1998	*Drawing Itself*, London Institute, London
	25 Years, The Butler Gallery, Kilkenny
1999	*54 x 54*, Times Building, London
	The Office of Misplaced Events, Lotta Hammer Gallery, London
2001	*Structurally Sound*, Ex Teresa Arte Actual, Mexico City
	Field Day, Taipei Fine Art Museum
	Double Vision, Galerie für Zeitgenossischekunst, Leipzig
	Close Encounters of the Art Kind, Victoria & Albert Museum, London
2001–3	*Multiplication*, organised by The British Council, touring to Romania, Croatia, Poland, Slovenia, Czech Republic, Estonia, Russia
2002	*Thinking Big: 21st Century British Sculpture*, Peggy Guggenheim Museum, Venice
	Groove, Huddersfield Art Gallery
2003	*Independence*, South London Gallery, London
	20:50, Saatchi Gallery, London
	Bad Behaviour, Longside Gallery, Yorkshire Sculpture Park
2003	*Wings of Art*, Stadt Aachen – Ludwig Forum für Internationale Kunst
	Marks in Space, Usher Gallery, Lincoln
2004	Galeria Fumagalli, Bergamo

Public works

1994	*Entrance to the Utility Tunnel*, Faret Tachikawa Urban Renewal Project, Tokyo
1999	*Over Easy*, The Arc Trust, Stockton-on-Tees
2000	*Slice of Reality*, North Meadow Sculpture Project, New Millennium Experience Company (NMEC), Millennium Dome, London
	Set North for Japan (74˚ 33' 2"), Echigo-Tsumari Art Triennial, Niigata Prefecture

| 2001 | *Off Kilter*, Millennium Square, Leeds |
| 2002 | *Final Corner*, World Cup Project, Fukuroi City |

Performance Works

1983	Started performance work with Anne Bean and Paul Burwell as the Bow Gamelan Ensemble. Performances in England, Scotland, Ireland, France, Belgium, Germany, Switzerland, Spain, Holland, United States and Japan. Recordings released through the Pulp music label and Audio Arts
	Choronzon, a performance assisting P.D. Burwell, Covent Garden, London
1985	*Once Upon a Time in the West End*, a performance assisting P.D. Burwell, Convent Garden, London

Selected Publications

1978	*12 Pieces*, Coracle Press, London
1980	*Wind Instruments*, Coracle Press, London
1985	*Sheer Fluke*, exh. cat., Matt's Gallery, London
1986	*Heatwave*, exh. cat., Ikon Gallery, Birmingham
	The Elements, exh. cat., Bookworks, London
1987	*TSWA 3D*, exh. cat., Gateshead
	Trigon Biennale 1987, exh. cat., Graz
1989	*Richard Wilson*, exh. cat., Matt's Gallery, London; Arnolfini, Bristol; Museum of Modern Art, Oxford
1990	'Edge 90 (Art & Life in the Nineties)', *Mediamatic*, vol.4, no.4, Summer 1990
	UK/USSR, exh. cat., The Showroom, London
1993	'On Siat: New British Sculpture', *Threshold* (Museet for Samstidskunst, Oslo), no.9, Jan.1993
	Another World, exh. cat., Mito Art Tower, Mito
	Richard Wilson, exh. cat., DAAD, Berlin
1994	*Watertable*, 45 rpm record commissioned by Arts Council Collection and National Touring Exhibitions, London, for Art Unlimited
1995	*Deep End*, exh. cat., British Council and Museum of Contemporary Art, Los Angeles
1996	*Mirades (sobre el Museu)*, Museu d'Art Contemporani, Barcelona
	Jamming Gears, exh. cat., Serpentine Gallery, London
	Islands, exh. cat., National Gallery of Australia, Canberra
1998	*Hung, Drawn and Quartered*, exh. cat., Stäädtisches Museum, Zwickau

2000	*Turbine Hall Swimming Pool*, exh. cat., Café Gallery, London
	Cultural Ties, exh. cat., Westzone, London
2001	*Field Day*, exh. cat., Taipei Fine Arts Museum, Taiwan
	Double Vision, exh. cat., Galerie für Zeitgenossischekunst, Leipzig
	Multiplication, exh. cat., The British Council
	Michael Archer, Simon Morrissey and Harry Stocks, *Richard Wilson*, Merell Publishers, London
	Thinking Big: 21st Century British Sculpture, exh. cat., Sculpture at Goodwood
2003	*100: The Work that Changed British Art*, Saatchi Gallery, London
	Bad Behaviour, exh. cat., Arts Council Collection
	Wings of Art, exh. cat., Kunsthalle Darmstadt
2004	*Bank Job*, exh. cat., Palazzo Delle Papesse, Centro Arte Contemporanea, Sienna

Television Programmes and Video Publications

1987	'Richard Wilson', Central Television
1988	'Alter Image' (about *20:50*), After Image Productions for Channel Four
1998	'Matt's Gallery: The Making of *She came in through the bathroom window*', The Late Show, BBC2
2002	'Richard Wilson', The EYE, Illuminations Television, (Video Publication)
2003	'History of British Sculpture', Channel 5

Works in Collections

Public collections include: Weltkunst Collection @ IMMA, Dublin; Boise; The British Museum; Government Art Collection; Arts Council of England Collection; British Council Collection; Ulster Museum, Belfast; Leeds Museums & Galleries; Lincoln City Museum; Centre of Contemporary Art, Warsaw; Museet for Samstidskunst, Oslo.

Private and corporate collections in the UK, USA, Italy, Spain, Australia, Germany, including the Saatchi Collection; British Land Corporation collection; Deutsche Morgan Grenfell Collection and Colección Bergé, Madrid.

Photographic Credits

Tate Publishing would like to thank the following individuals for their photographs of Richard Wilson's work, a selection of which are reproduced in this volume:

David Allen; Shigeo Anzai; Jon Bewley; Steve Collins; Sean Dower; Rose Garrard; Ken Gill; Hugo Glendinning; Jim Harold; Naoya Hatakeyama; Ronnie Israel; Kathy Kenny; Robin Klassnik; Jaroslaw Koslowski; Mark Lucas; Roberto Marossi; Ohta; Anthony Oliver; Anne Painter; Paul Pederson; Steve Percival; Martin Garcìa Perèz; Antonia Reeve; Sakomizu; Ed Sirrs; Kier Smith; Morton Tholkilsden; Rod Tidnam; Jane Thorburn; Rodney Todd-White & Son; Stephen White; Richard Wilson; Tim Wilson; Edward Woodman; Bill Woodrow; Silvia Ziranek

Photographic credits for works not by Wilson are as follows:
Courtesy the artist 44, 101
Courtesy the Estate of Gordon Matta-Clark and David Zwirner, New York 68, 76
Documenta Archiv, Kassel 51
Rita Harris 3
SFMOMA/ Ben Blackwell 90
Courtesy Waddington Galleries 100

Index